IMAGES
of America

MOUNT PROSPECT

IMAGES
of America

MOUNT PROSPECT

Gavin W. Kleespies and Jean Powley Murphy

ARCADIA
PUBLISHING

Copyright © 2003 by Gavin W. Kleespies and Jean Powley Murphy
ISBN 978-0-7385-3165-6

Published by Arcadia Publishing
Charleston SC, Chicago IL, Portsmouth NH, San Francisco CA

Printed in the United States of America

Library of Congress Catalog Card Number: 2003107807

For all general information contact Arcadia Publishing at:
Telephone 843-853-2070
Fax 843-853-0044
E-mail sales@arcadiapublishing.com
For customer service and orders:
Toll-Free 1-888-313-2665

Visit us on the Internet at www.arcadiapublishing.com

CONTENTS

INTRODUCTION

The Mount Prospect we know today is a developed suburban community, with an extensive school system, active government, and many cultural and social organizations. However, at one time, Mount Prospect was a very different place. This area was once the hunting grounds of the Potowatomi. In time, the Potowatomi were displaced by Yankee settlers, who were themselves replaced by German immigrant farmers. During the 20th century Mount Prospect slowly became more diverse. Then, in the 1950s, the population exploded. Like many of the surrounding communities, Mount Prospect evolved into a suburb of Chicago, instead of remaining the rural farming community it had once been.

The first inhabitants of the area that is today Mount Prospect were Native American Indian tribes. Although few specifics are known about the individuals who lived here prior to European exploration, there is reason to believe that there may have been temporary or semi-nomadic settlements in this area. By the 18th century the Potowatomi tribe inhabited this region. American and European settlers co-existed here with members of this tribe for a short time, but there was no extensive trade between the groups. The influx of settlers to northern Illinois did not begin until a few years following the conclusion of Black Hawk's War (1832), so there was limited contact between groups. After the Potawatomi ceded all of the land in the area surrounding Chicago (including what would later become Mount Prospect) to the Federal government in the treaty of 1833, the land here became available for pioneer settlers.

The first Yankee settlers in this area arrived in the mid 1830s. There had been some settlement in Chicago and the Midwest earlier, but because of the hardship of the trip and safety concerns prior to the 1833 treaty, northern Illinois had few settlers before 1835. Before the Erie Canal was completed in 1825, moving west had been a long, hard journey filled with uncertainty. The canal connected the Great Lakes to the Hudson River and from there to the Atlantic Ocean, so settlers could now move at much greater speeds, taking along more belongings. The increased traffic also meant that the settlers could receive supplies in a fraction of the time. Shortly after the completion of the canal, masses of people from New England and New York began migrating to the Midwest.

When the first American settlers came to what would later become Mount Prospect, they found a wide-open space covered in prairie grasses that stood four feet tall. Yankees were the first settlers to the area and the first to clear the land and establish farms. However, by around 1850 most of these first settlers had left the area. They left for different reasons—some were adventuresome and went further west, others headed for the coasts, either drawn by the gold rush in California or moving back to New England.

The second group to come to this area was the German immigrants. The largest wave of German immigrants to America came between the early 1840s and the late 1860s. These

German immigrants often moved onto established farms sold by Yankees, and subsequently forged communities that were entirely German. This is the story of Mount Prospect; it was settled by German Lutherans. What the German settlers did, that the Yankees had not, was work to establish a community. Much like the Puritans before them, many Germans came to the "New World" to preserve traditional religious and cultural practices that they felt were threatened in Europe. Because of this, it was important that they quickly establish institutions to pass on these cultural traditions. This is why Saint John Lutheran Church was founded in 1848, within months of the first German's arrival in the area.

Two years later, in 1850, the railroad came to the area. Although there was no station for Mount Prospect, the farmers could travel to nearby towns, such as Arlington Heights and Des Plaines, to sell their goods. The person who decided to establish a town here was a man named Ezra Eggleston. In 1874 he bought most of the land that later became downtown Mount Prospect. Eggleston built a train station, platted roads, and divided the land up into parcels. He also gave Mount Prospect its name. "Mount" was because the land sits on some of the highest land in Cook County, and "Prospect" was to proclaim that there were great prospects in this area. Eggleston meant to make his fortune from this development; however, he had poor timing. In 1871, three years before Eggleston started building, the Chicago Fire blazed through downtown. Many potential customers were rebuilding, not looking for new land. It was also just a year after the start of the Panic of 1873, which lasted for most of the decade and was called the "Great Depression" until the one in 1930. There were few people interested in the land speculation.

Although Ezra was not very good at making money, he gave the town its name and built the first train station. He also laid the roads and divided the village into the blocks that we all know today. A couple of years after Ezra sold his interest in the community, other people began building stores and houses in the area he had platted and made the Village of Mount Prospect come to life. In 1880, the first store was built in Mount Prospect; in 1883, a blacksmith put up a shop; and in 1885, the first tavern opened and the first post office was set up. With all of this development, more people started to move to the area, and with a station available, the train now stopped in Mount Prospect, but only when flagged down.

The town continued to develop, and in 1917 Mount Prospect was incorporated. In the 1920s, with a number of large subdivisions, the town became more diverse as non-Germans began moving into the area. The Great Depression and World War II halted growth for awhile, but it was inevitable. After the war, migration from the city resumed to such an extent that between 1950 and 1960 the population grew almost 500 percent. First the village went through the growing pains involved with having a large youthful population and the need for more schools and services. Later, in the 1970s, the village had to deal with a large number of empty nesters and the need for fewer schools and different services. The village has continued to adapt and has attracted a more stable, diverse population, which will greet the transitions to come. In this book, we will use photographs to document the transitions that have made Mount Prospect the place we know today.

One

GERMAN MIGRATION

OLD WORLD TRADITIONS IN THE NEW WORLD, 1870–1900

Mount Prospect, Illinois, like many other communities across the upper mid-west, has a long immigrant tradition. The settlers who established a community here were almost exclusively immigrant farmers from the Germanic states, and they maintained their "old world" traditions throughout the 19th century. In the following chapter we will see how these people lived, what the community they created looked like, and how that community became the Mount Prospect we know today.

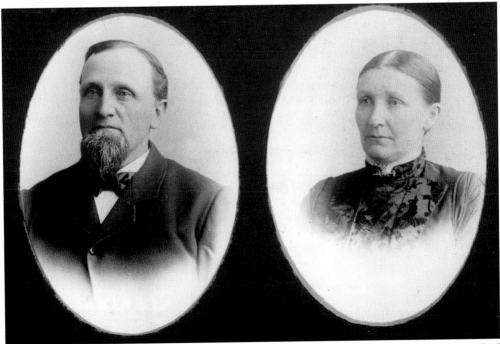

CARL AND SARAH BEHLENDORFF, C. 1870. Like many of Mount Prospect's first residents, Carl Behlendorff was a German immigrant. He had been born in Hanover, Germany and moved to America when he was 11 years old. Fourteen years after he arrived, he married Sarah Lehman and moved into their Mount Prospect home, which is still standing at 407 North Prospect Manor, one of the few pre-Civil War homes still standing in Mount Prospect. Unlike the majority of their neighbors, the Behlendorffs were Methodists, not Lutherans.

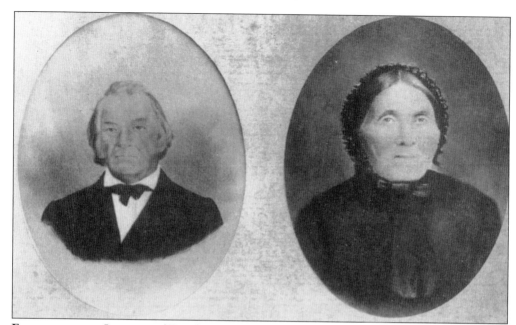

FRIEDRICH AND JOHANNA (KATZ) BUSSE, C. 1866. Friedrich and Johanna were the first members of the Busse family to arrive in Mount Prospect. Like Carl Behlendorff, they were born in Hanover, Germany. They immigrated to the United States in 1848 and began looking for land to farm. They eventually purchased an existing farm from an innkeeper named Samuel Page. Their descendants have continued to be some of the most prominent members of the Mount Prospect community even today.

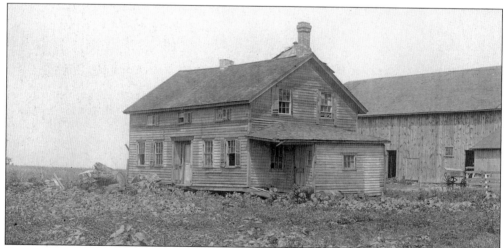

BUSSE HOMESTEAD. In 1848 Friedrich and Johanna Busse set off with five of their children, Christian, Friedrich, Louise, Louis, and Johanna, to settle in America. They were following their third son, Henry, who had set out to make his fortune in the new world a year earlier. He had sent letters home extolling the land and freedom of America, and Friedrich decided to follow. Like many German immigrants, the Busses did not clear the land. After investigating a number of locations, they purchased an existing farm, with a house, tools, and crops in the ground. Through hard work and careful planning, the Busse homestead prospered and grew. The land and home remained in the Busse family for the next century.

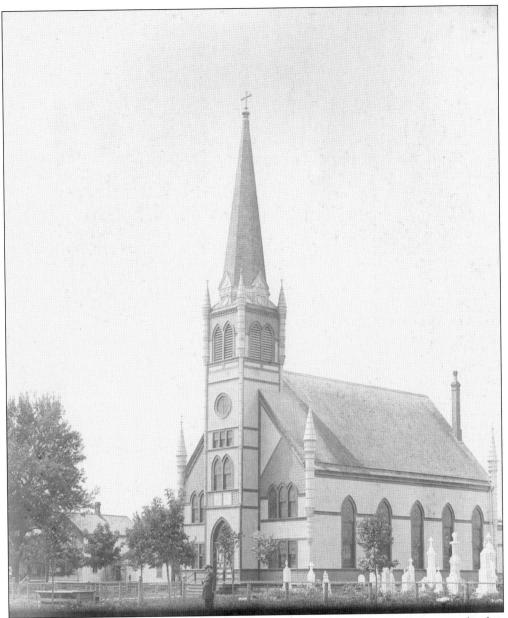

THE THIRD SAINT JOHN LUTHERAN CHURCH, C. 1900. Saint John Lutheran was the first church constructed in the area that would later become Mount Prospect. The congregation was formed by recent German immigrants who were interested in creating organizations that would preserve their cultural heritage. The first church, a small one-room building, was built in 1848. In 1854, a larger building with a steeple was constructed. This was replaced by the third structure in 1894 (started in 1892). It is still standing today, although there is a large addition to the front, and it lacks the original steeple, which blew over in a 1979 wind storm.

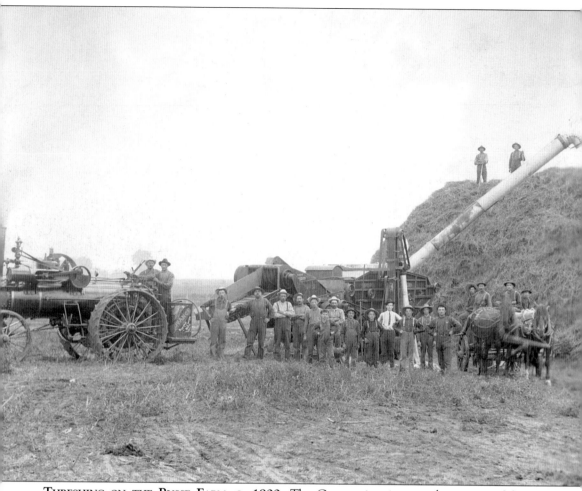

THRESHING ON THE BUSSE FARM, C. 1900. The German immigrants who came to Mount Prospect hoped to find land they could farm and a place to start a traditional Lutheran community. These two goals dovetailed, as the bonds that were established through this community were of great use during harvest time. Farming in the 19th century was very labor intensive, so neighbors would pitch in and help each other. This made it possible to clear more land and work larger farms. The farm in this picture was near Algonquin, Elmhurst, and Wille Roads in an area of Des Plaines just north of Majewski Metro Park. Some of the adults pictured here are Louis Busse, Martin Busse, Bill Boeckenhauer, Lou Linneman, Henry Linneman, and William Wille.

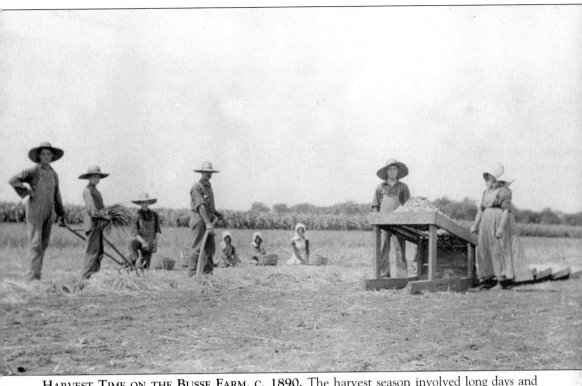

HARVEST TIME ON THE BUSSE FARM, C. 1890. The harvest season involved long days and hard work, as seen here on the Busse family homestead. The man and woman to the right are sorting the grain from the chaff on a screen, while the man standing in the middle is holding a sythe, used to cut down tall stalks. The children sitting with buckets are sorting through the cut stalks to find the grains, which will then be sorted through the screen.

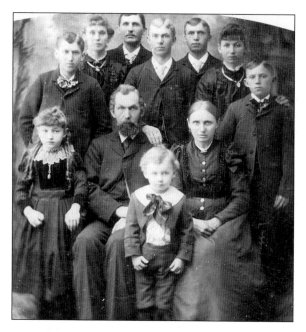

LOUIS BUSSE FAMILY, C. 1893. Louis Busse came to America with his parents at the age of 11. While maintaining a strong belief in traditional customs, he also adopted many American ways. As tradition prescribed, he, as the youngest son, took care of his parents in their old age and eventually took over the family homestead. However, he also was the first Busse in America to decide to go into a business outside of farming and to get involved in the larger political discourse. In 1880, he opened a creamery and general store in what is now Arlington Heights, and served for almost 30 years as the director of public School District 56. He also was the highway commissioner in Elk Grove Township for 27 years, and served on the board of trustees for Saint John Lutheran Church. His example was certainly taken to heart by his oldest son, William Busse (seen in the back row to the left), who would go on to be a Cook County commissioner, the first mayor of Mount Prospect, and an important business owner.

EZRA AND AGNES EGGLESTON, C. 1880. Ezra Eggleston is responsible for naming Mount Prospect, as well as building the community's first train station and platting its streets. He was a Chicago developer who believed that he would become rich from land speculation along the Chicago Northwestern Rail Line. He purchased land in 1874 and named the area Mount Prospect, to reflect its high elevation along a glacier ridge and its great prospects for the future. However, he was not destined to make his fortune here. The Great Chicago Fire of 1871 and the economic Panic of 1873 combined to squash his dreams. By 1882, Eggleston had gone bankrupt and lost all of his holdings in the community; however, his legacy lives on in the name of the town and the design of the downtown.

THE OWEN ROONEY HOUSE. This is the oldest house in Mount Prospect, although the exact date of its construction is not known. Owen Rooney was born in Ireland some time around 1815 and moved to the Mount Prospect area from Wisconsin in 1847. He purchased a 160 acre farm, and it is not known if a house was already standing on the property. The Owen Rooney house seen in this picture was most likely built after 1850, as it has side paneling made of mill cut wood. The first mill in the area was started in 1852 by Socrates Rand, the man for whom Rand Road is named, and the train did not come through Mount Prospect until 1850, so it would have been very difficult to find milled wood prior to that. Ezra Eggleston purchased a part of Owen Rooney's farm when he began to develop what is today downtown Mount Prospect. Later, most of Rooney's farm was subdivided by William and George Busse into Busse's Eastern Addition. The home has had major additions over the years, so you cannot see the shape of the original building, although it is still standing.

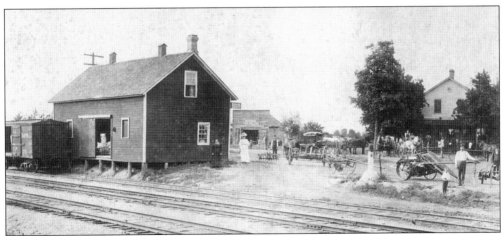

FEED AND SEED RAILROAD WAREHOUSE, C. 1886. John Conrad Moehling ran the first general store in Mount Prospect. He was also the first postmaster and the first depot agent in Mount Prospect. The barn-like building was a warehouse, built along the first side track in Mount Prospect. In this photograph you can see a farm equipment dealer to the left and Moehling's General Store/Post Office to the right. John Moehling is the adult standing closest to the tracks on the right.

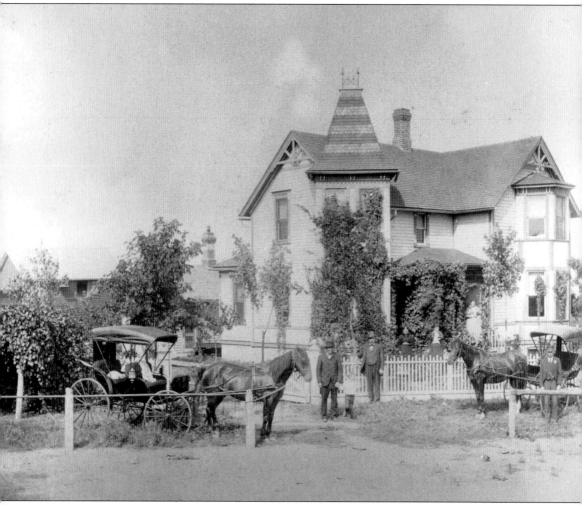

JOHN CONRAD MOEHLING HOUSE, C. 1895. Henry Conrad and Sophia Pullman Moehling emigrated from Germany in 1848, and purchased a farm in what is today the southern part of Mount Prospect. Two years later, John Conrad Moehling was born. He grew up in the area, and purchased his own farm in Elk Grove in 1873, but soon found that the farming life was not for him and leased out his farm in 1882. He then purchased the store that County Commissioner Christian Geils had established a year earlier in the tiny town of Mount Prospect. Moehling began selling farm tools, coal, seed, feed, groceries, shoes, etc. In 1885, he wrote to Washington, D.C. and applied to have a post office established in Mount Prospect. On December 31, 1885, John C. Moehling was appointed the first postmaster of Mount Prospect. In the early 1890s, Moehling built this house at 8 East Northwest Highway. It was demolished in 1966.

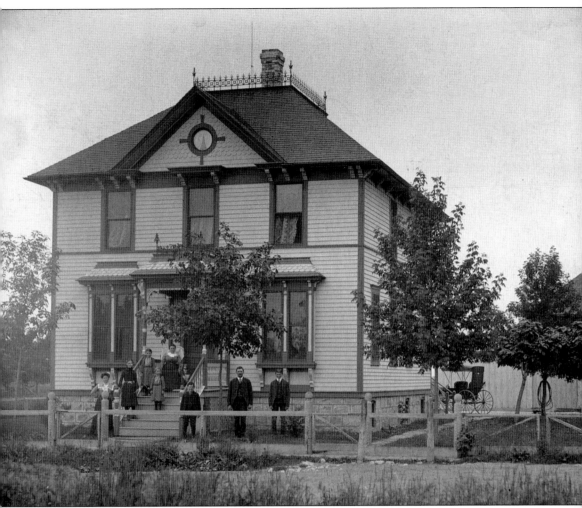

WILLIAM BUSSE HOUSE, C. 1895. Cook County Commissioner William Busse was probably the most influential person in Mount Prospect's development. He was responsible for the founding of the Mount Prospect State Bank, Busse Buick, and Busse Hardware, and for the construction of the Central School and the Northwest Highway. What he didn't start himself, he probably financed. His house was certainly the finest in Mount Prospect, with formal gardens laid out behind it. It was even used for a couple of weddings in the community, as it was the most formal space in town. The house stood at the southeast corner of Main Street and Busse Avenue. It was moved twice, first slightly to the southeast to face Emerson Street and then, in 1958, to Central Road. In the picture, from left to right are Martha, Mathilde, Helen, Sophie Bartles, Albert E., William, and William Jr.

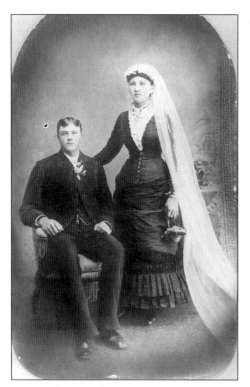

MOELLENKAMP WEDDING PICTURE, 1884. This hand-colored photograph is the wedding portrait of John Henry and Alvina Gewecke Moellenkamp. Both are dressed in black, in keeping with German traditions and frontier practicality, as the clothes would be reused. The fact that black clothes faded after the first wash showed that, in wearing black, you were wearing brand new outfits. The bride's white veil was probably rented from the photographer for the picture, as lace veils were prohibitively expensive. The family lived along Golf Road in what is today the southern section of Mount Prospect, and raised eleven children.

LOUIS C. AND LOUISE MEIER BUSSE WEDDING PICTURE, C. 1888. Wearing the traditional black wedding dress and suit, Louis and Louise were married. They produced three sons, Alfred, Arthur, and Fred. Louis and his son Fred later founded Busse Flowers, moving from traditional farming to a cash crop. The flowers were raised in greenhouses and then shipped to Chicago by train.

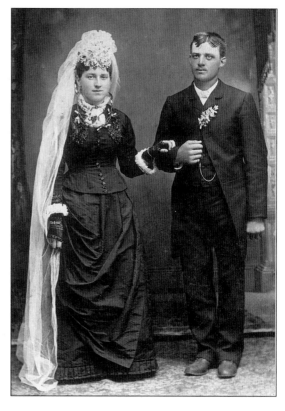

ALFRED, ARTHUR, AND FRED BUSSE, 1900.
Alfred, Arthur, and Fred were the children of
Louis C. and Louise Busse. Each of them left
their own unique mark on the community.
Arthur took over the family homestead at
the corner of Oakton and Elmhurst Roads.
Alfred started his own farm along Landmeier
Road, which remained a working farm in
the Busse family into the 1950s. Fred and his
father later started Busse Flowers.

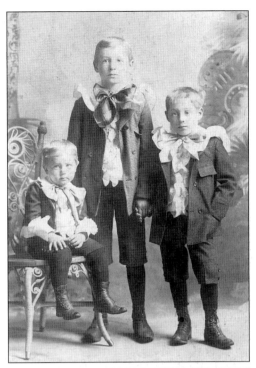

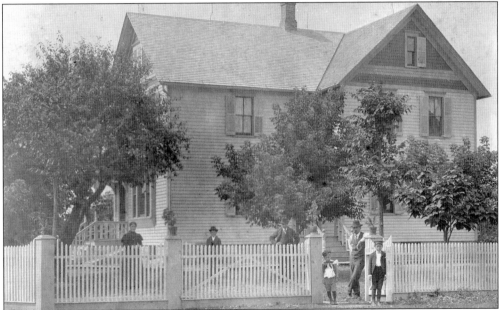

LOUIS BUSSE HOME, C. 1899. This home stood on the northwest corner of Elmhurst and
Oakton Roads. Standing at the gate are Arthur W. Busse and Fred W. Busse. Fred Busse later
went on to found Busse Flowers with his father, Louis Busse, who is also standing at the gate.
Busse Flowers has become the longest continually running business in Mount Prospect, and is
still owned and operated by Fred Busse's descendants. In the early 20th century, Mount Prospect
was a large-scale producer of flowers. Busse Flowers had a large greenhouse and there were also
two other big greenhouses in town.

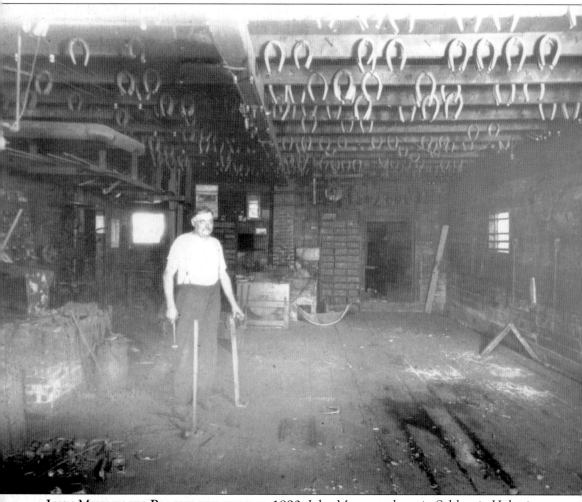

JOHN MEYN IN HIS BLACKSMITH SHOP, C. 1890. John Meyn was born in Schleswig-Holstein, and immigrated to America in 1882 at the age of 19. He worked as an assistant blacksmith in Arlington Heights for a year before he was persuaded by John C. Moehling, Mount Prospect's first postmaster and owner of the general store, to move to Mount Prospect and open his own shop. He was the first blacksmith in town and ran the business for many years.

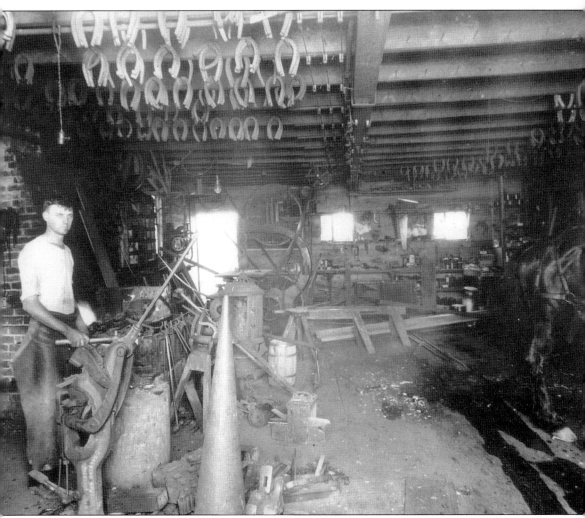

HERMAN MEYN IN JOHN MEYN'S BLACKSMITH SHOP, C. 1890. Herman Meyn was the son of John Meyn. He worked for many years as a blacksmith in his father's shop. But he also believed in changing with the times, so he began selling motorized farming tools and later, lawn mowers. Herman was one of the first people born in Mount Prospect. When he was born, the population was less than 100 and his parents and six brothers and sisters made up a good part of it. He was very involved in the growth and development of Mount Prospect, serving as one of its first trustees in 1917 and then as the second mayor of Mount Prospect from 1929 to 1937, through the Great Depression. He stayed true to Mount Prospect's traditionally conservative, German background, and consequently this community was one of the few in Illinois that never approached insolvency.

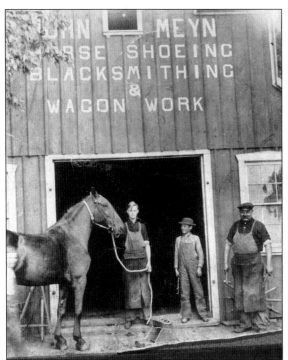

JOHN MEYN'S BLACKSMITH SHOP, c. 1885. The blacksmith shop in Mount Prospect was located on Northwest Highway, just past Main Street. Having a blacksmith shop was an early step toward development. When most transportation required horses, you needed to have someone in town who could shoe the horses and repair wagon wheels if you expected the town to grow. This is why John Moehling went out of his way to persuade John Meyn to move to Mount Prospect.

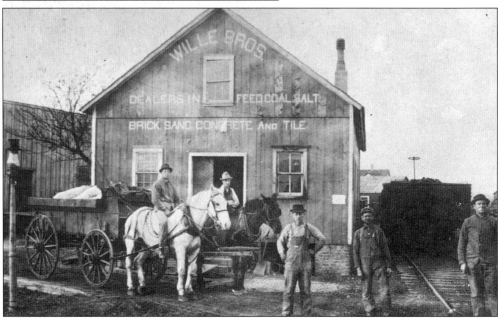

WILLE BROTHERS COAL AND LUMBER, c. 1900. The Wille family was also very prominent in the development of Mount Prospect. William Wille started a creamery in Mount Prospect in 1880, taking milk from the local farmers and turning it into butter and cheese to be sold in Chicago. He later became a carpenter, building a number of important buildings, including the Central School, Wille Hall, and a number of houses that are still standing. Around 1900, William's sons started Wille Brothers Coal and Lumber, which supplied the community with building materials for more than 70 years.

BARN AT LOUIS F. BUSSE FARM, C. 1904. Louis F. Busse was the sixth of Louis Busse's nine children, which also included Cook County Commissioner William Busse and George Busse of Busse Realty. While his brothers became major developers in Mount Prospect, Louis F. Busse decided to follow the family tradition and stayed in the country. His farm stood at the corner of Oakton and Busse Roads, and he farmed the land for over 50 years before the suburban expansion eventually caught up with his farm.

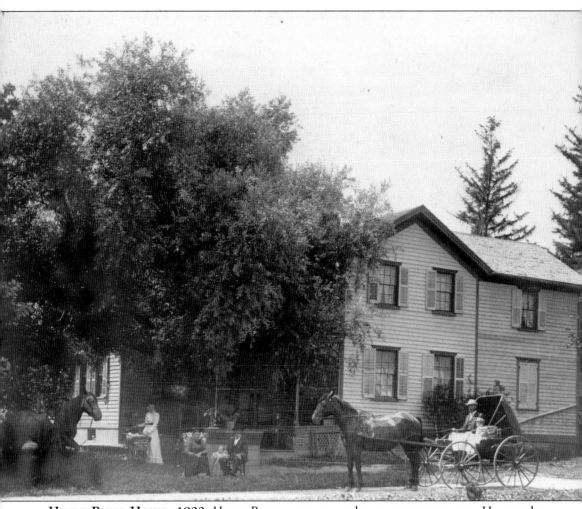

HENRY BUSSE HOUSE, 1900. Henry Busse was a very adventurous young man. He was the first of the Busses to come to America in 1847. Being the third son of Friedrich and Johanna, he had no hope of inheriting the family farm in Germany, so he set off to the new world. His letters home, describing the wealth and opportunity in America, eventually brought the rest of the Busse family to Mount Prospect. Henry Busse was not yet done traveling, however. In 1849, he set off for California to make his fortune in the gold rush. While he did not make a fortune, he did a lot better than most who were there, and came home with enough money to purchase a farm at what is today the intersection of Busse and Algonquin Roads. In this photograph, Martin and Elmer Busse are in the carriage, Henry and Mary Behrens Busse are seated, and Dorthea Wille Busse is standing with her daughter, Mabel, who is in the baby carriage.

WILLE HALL, C. 1900. William Wille worked extensively with William Busse and other local leaders to improve the community. When Wille Hall was built, the village was not yet incorporated, the population was less than 100, and, other than the Central Schoolhouse, there were no public meeting places. William Wille built the hall to be a gathering place for local clubs and organizations. Dances and other events were held in this building, and it became central to the growing community. The building was demolished in the 1940s.

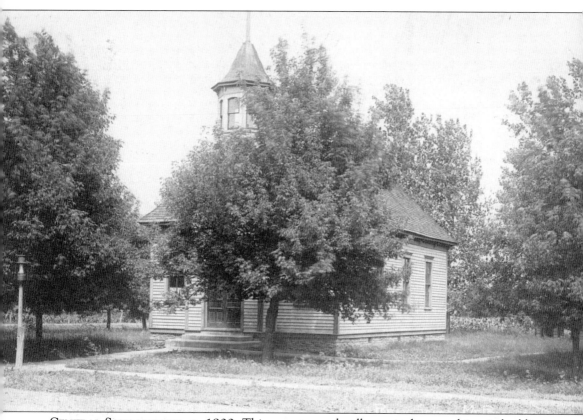

CENTRAL SCHOOLHOUSE, C. 1900. This one-room schoolhouse is the most historic building standing in Mount Prospect. Built in 1895, it was the first home of School District 57, which was the first school district in Illinois to cross township lines. The district was created largely through the efforts of Cook County Commissioner William Busse, Mount Prospect's biggest promoter. He believed that the community would not attract new residents without a public school, and therefore carved District 57 out of portions of Elk Grove and Wheeling townships. The schoolhouse was also used for meetings and social events. The papers of incorporation for the Village of Mount Prospect were even signed in this building in 1917. It was also the first home of the Mount Prospect Public Library, the fire department, the Women's Club, Saint Paul Lutheran Church, Saint John Episcopal Church, the first kindergarten, and the first movie theater in Mount Prospect.

Two

CONTROLLED DEVELOPMENT

TOWN LEADERS WORK TO IMPROVE AND INCORPORATE THE TOWN, 1900–1930

Following the rise and fall of the first land speculation in Mount Prospect, the longtime residents of the area began to move into and develop a town. Showing their traditional, conservative heritage, these developers took a measured and reasonable approach to the development. The town grew rapidly, but not without caution and supervision. It became increasingly diverse, with new residents moving in from Chicago and other areas. World War I made many German communities around America downplay their history, and Mount Prospect reflected this trend. In this period, churches began offering services in English, and with the arrival of new, more diverse residents the town began to see itself as much more American.

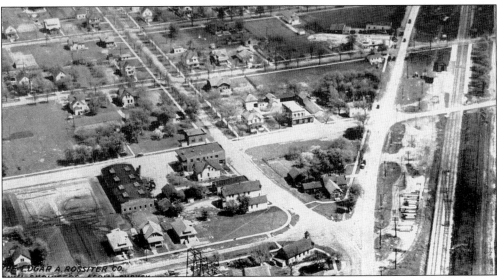

AERIAL VIEW OF MOUNT PROSPECT, 1923. This bird's eye view shows most of the developed area of downtown, as well as the agricultural areas surrounding the community. The small triangle is the meeting of Busse Avenue and Northwest Highway. Inside the triangle you can see the Meyn Blacksmith Shop, Wille Hall, Baldini's Barber Shop, Wille's Tavern, the Busse Hardware Store, and finally a small brick building that was the first home of the Mount Prospect State Bank. In the upper left hand corner, you can see the first Saint Paul Lutheran Church and in the right hand corner, both Crowfoot Manufacturing and the greenhouse for Busse Flowers. We will see closer views of each of these buildings in the following chapter.

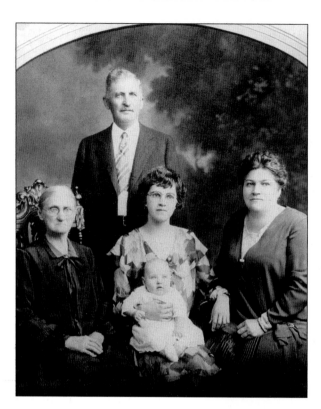

FOUR GENERATIONS WITH WILLIAM BUSSE, C. 1912. William Busse was involved in almost everything that went on in Mount Prospect, but he also made time for his family. He is seen here with his mother, Christine (Kirchhoff) Busse, his second wife, Dina Busse, and a daughter and granddaughter.

DIETRICH AND LENA FRIEDRICHS WEDDING PICTURE, 1904. Dietrich and Lena were both born in America to German families and both grew up on farms. They were also both from large families, having 10 siblings each. In many ways, Dietrich and Lena reflect what was happening in the community on a larger level. They maintained many of the traditional values but moved away from the farm towards a small town life-style. After they married, they decided to go a different way than their families, and in 1906 moved into a home at 101 South Maple Street in downtown Mount Prospect—the home that is now the museum of the Mount Prospect Historical Society. They had only one child, Bessie, and Dietrich worked as a house painter and decorator rather than on a farm.

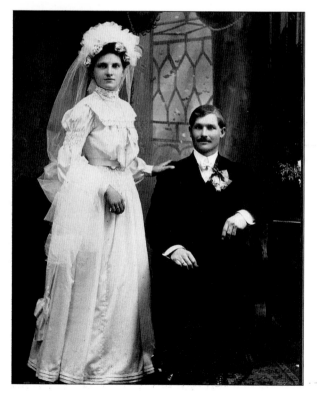

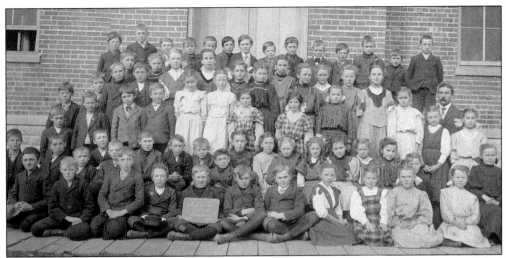

SAINT JOHN SCHOOL, 1908. When the first German settlers came to Mount Prospect they were interested in starting organizations that would maintain their cultural and religious traditions. One of the reasons they came to places like Mount Prospect was because they felt that their traditional religious practices were being threatened in Europe by increasingly cosmopolitan factions within the Lutheran church. Like the Puritans 200 years earlier, they wanted to own land in an area that would have enough freedom to maintain their old-world, traditional beliefs. Soon after the first German families arrived in what would become Mount Prospect, they founded Saint John Lutheran Church. The first Saint John School was founded in 1853, and was held in the building used as the original church. A second school was built in 1864, and finally the school seen in this picture was built in 1901. In 1958, a new building was constructed, which is still in use today.

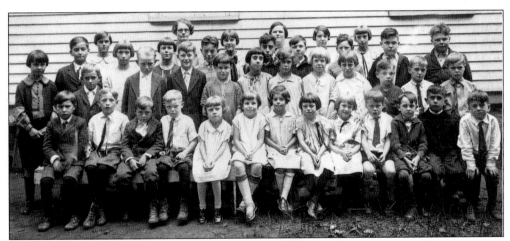

CENTRAL SCHOOL, C. 1915. Central School was a top-of-the line one-room schoolhouse. The design of the building was made with an awareness of the most current academic standards in the state. The fact that the building faced north and had twice as many windows on one side was not an accident. This was in keeping with the belief that the amount and direction of light in a school would affect the learning of the students. If you read the 1908 publication by Francis G. Blair, superintendent of public instruction, *The One Room and Consolidated Country Schools of Illinois*, you will see that the Central School was not an anomaly but was on the cutting edge of public education for its time.

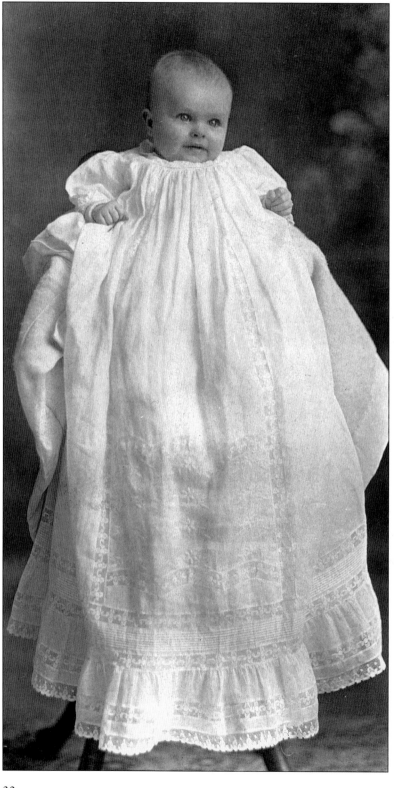

BESSIE FRIEDRICHS, 1911. This baby picture of Bessie Friedrichs shows her in a swaddling gown. These large gowns were worn by small children in the 19th century. The length of the gowns was normally twice as long as the child; the extra material would be twisted and tucked underneath the baby as insulation to keep him or her warm. This was known as swaddling. Bessie is seen here in one of the traditional gowns. She was born into a community that was changing from a traditional German village to a more cosmopolitan town. Her baby picture shows the links that her parents still had to traditional ways, although their choice to move off of the farm and into town showed a movement toward a modern lifestyle.

BESSIE FRIEDRICHS, C. 1912. Bessie was the only child of Dietrich and Lena Friedrichs. When the Friedrichs built their house on Maple Street, it was the thirteenth house in Mount Prospect. Looking behind Bessie in this picture, you can see that there appears to be a farm right next door. This picture of a small farming community makes you appreciate the fact that Dietrich's decision to make a career of house painting was actually quite daring at the time.

ARTHUR AND FRED W. BUSSE AT RIVERVIEW PARK, C. 1910. Fred and Arthur Busse are seen here posing for a photograph with a man named John Peters, a teen from a local orphanage. The Riverview Park was an early amusement park that was developed by William and George Schmidt, Chicago-based real estate speculators. The park, located on the north side of Chicago, started as a shooting range called Sharpshooter's Park with some amusements for the wives and children. However, the amusements soon surpassed the shooting range in popularity, and Riverview was born. The amusement park developed into something in between a modern amusement park and Coney Island. With rides, games, shows, and a large midway for strolling, the park had something for everyone. More than anything, it had lots of new and different people. This was a tremendous attraction for people from a small town like Mount Prospect, and most certainly would have been something that Arthur and Fred remembered for years.

FRED BIERMANN AND TEAM, C. 1915. Fred Biermann was Mount Prospect's first teamster. He was brought to Mount Prospect by William Busse and the Mount Prospect Improvement Association. They were interested in furthering the development of the community and wanted to improve the roads to help reach this goal. They lured Fred Biermann from Elk Grove because they were looking for a teamster who could work on the grading of the streets. Fred Biermann worked for years, improving, leveling, repairing, and grading the gravel roads in town. Fred's son Frank later married William Busse's daughter Helen, became involved in many aspects of community life, and ran the Busse-Biermann Hardware Store, which was a downtown fixture for a generation.

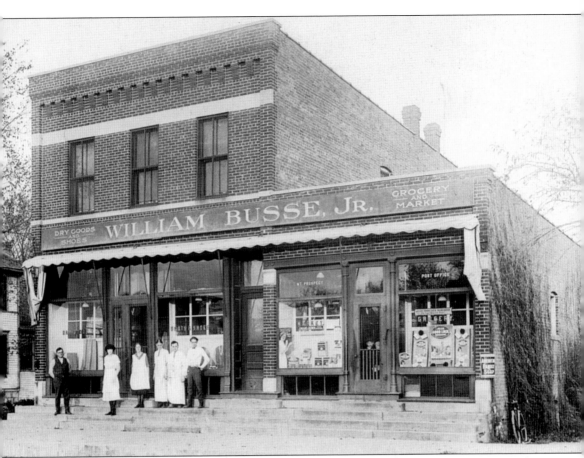

WILLIAM BUSSE JR.'S DRY GOODS STORE, C. 1915. William Busse Jr. was Commissioner William Busse's eldest son. However, he followed in his grandfather's footsteps more closely than in his father's. He did not go into political life as his father had, but opened a general store as his grandfather, Louis, had done. Louis had been the first of the Busse family to open a business and move away from farming when he opened a general store and creamery in 1880 at the intersection of Algonquin and Arlington Heights Roads. William Busse Jr. is the man standing farthest to the left in this picture. Originally the one-story addition to the building was a separate store run by a man named John Bauer.

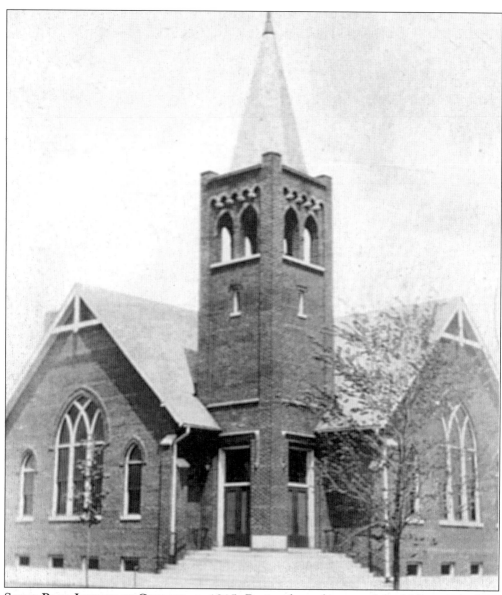

Saint Paul Lutheran Church, c. 1915. During the early years of the 20th century there was no church in downtown Mount Prospect, and this was a hardship for its residents. Saint John Lutheran Church, the first congregation in the community, was located on Linnemann Road, a little over a mile from downtown. This could be a long walk, especially in the winter, so in 1912 a group of local leaders got together to organize a new church. After receiving a charter from the state, Saint Paul Evangelical Lutheran Church was founded. William and Edward Busse donated land for it, and everyone began looking for a Pastor for the new congregation. Henry Haberkamp, a founding member of Saint Paul, eventually found one. Haberkamp was in the wholesale dairy business, and one day he was talking to one of his clients about the hard time they were having locating a pastor. This man told Haberkamp that the minister of his church had a son who was a minister and was in North Dakota freezing to death. Haberkamp looked into it, and soon they were able bring J.E.A. Mueller Jr. to the warmer climate of Mount Prospect, as the first pastor of Saint Paul.

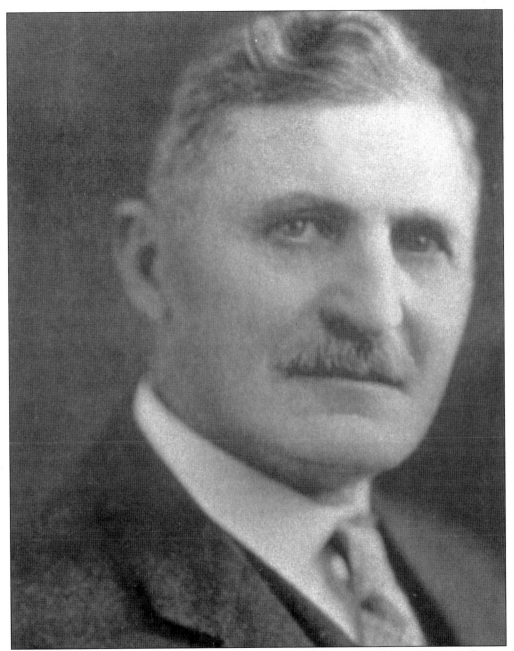

MAYOR WILLIAM BUSSE, 1917. William Busse was the first mayor of Mount Prospect; he was also probably the most important person in the development of the town. As a Cook County commissioner, Busse had political experience and regional connections before he became mayor. He was the driving force behind the construction of Northwest Highway, the road that put Mount Prospect on the map. He was also largely responsible for the founding of School District 57 and the construction of the Central School, Mount Prospect's first public school. Busse's civic improvements were also helped by his business investments. He founded the Mount Prospect State Bank, which for years was the only bank in town. This bank made most of the loans to the buyers who built homes in Mount Prospect in the 1920s through the 1950s.

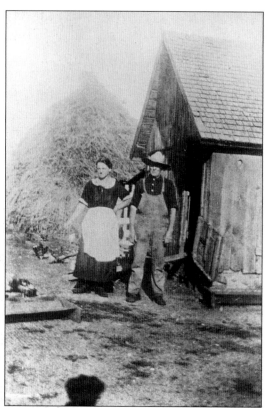

THE OTTO AND PAULINE RATEIKE FARM, c. 1917. The Rateikes, seen feeding the chickens, give a glimpse of farm life in Mount Prospect in the 20th century. A number of farms survived in the area into the 1950s, although by the 1920s the transition to a suburban community had begun. Otto and Pauline, who were born in 1878 and 1884, were part of a generation that grew up in a quiet farming community and lived to see the dramatic post-war expansion of Mount Prospect into a modern suburban community.

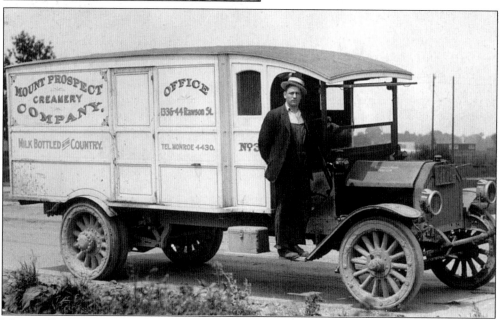

MOUNT PROSPECT CREAMERY TRUCK AND DRIVER, 1915. The Mount Prospect Creamery was founded in 1910 and had its main factory on Northwest Highway near School Street. It employed 13 drivers who delivered the bottled milk around the northwestern communities and into Chicago. Notice the advertisement on the side of the truck, "Milk Bottled in the Country."

MAIN STREET NORTH OF CENTRAL AVE, 1917. Mount Prospect looked a little different when it was incorporated in 1917 than it does today. One thing that is often forgotten about Mount Prospect is that it was originally a prairie. Today it is hard to see that, but looking at this picture you can see how flat and open the area was. This image of Main Street shows the open space and farm land that made up most of Mount Prospect. This view today would be looking straight toward Randhurst Mall and would be completely lined with houses.

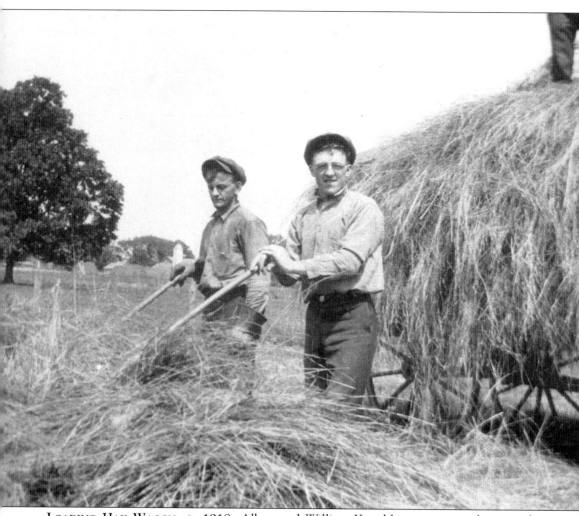

LOADING HAY WAGON, C. 1918. Albert and William Kerschke are seen working on the family farm along River Road. Although the northwest suburban area had good farmland and was close enough to Chicago to ship goods profitably, it was still hard work to have a farm. As development increased and the land values grew, many farmers subdivided their property and moved to less demanding jobs.

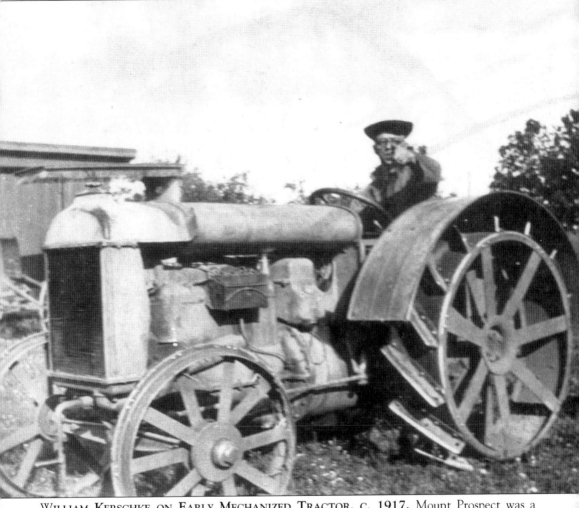

WILLIAM KERSCHKE ON EARLY MECHANIZED TRACTOR, C. 1917. Mount Prospect was a fertile and profitable farming community. Its proximity to Chicago, which by the early 20th century had become a major industrial center and the second-largest city in America, gave local farmers access to a gigantic market. Many of the neighboring communities had developed more extensively, removing more land from farming, which gave the remaining farmers an added advantage. The endless demand for their products in the city and the relatively cheap transportation gave the local farmers a good profit margin, so they were able to reinvest a portion of their profits in the latest technology, such as this tractor.

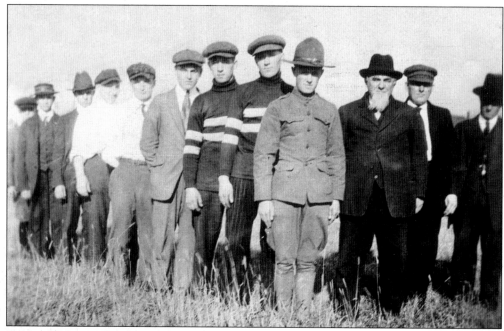

EDWIN WILLE IN WWI UNIFORM, 1918. World War I changed Mount Prospect forever. The village was founded by German Lutheran families who wanted a community that would maintain German traditions. When America went to war against Germany, this became a more complicated issue and traditions began to change. Many in Mount Prospect, such as Edwin Wille, showed their American patriotism and joined the U.S. military. The community also began to become more diverse and accepting of non-German families moving into town. Seen in this photograph is Edwin's father, William Wille (standing next to him in the dark suit), his brother Albert to the far right, and the Mechlenburg brothers in matching striped sweaters to the left.

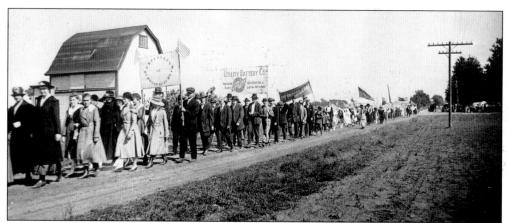

ARMISTICE DAY PARADE, C. 1918. Many of Mount Prospect's residents marched in this early parade. Some of the major businesses had banners, such as the Mount Prospect Creamery and the Utility Battery Company, as well as a banner for the village. With numerous American flags, one can see the demonstration of patriotism in the town. It is not known what street this parade marched down; perhaps it was Central Avenue, Rand or Prospect Road. The first streets to be paved in Mount Prospect were not laid until the 1920s, in Axel Lonnquist's luxury subdivision.

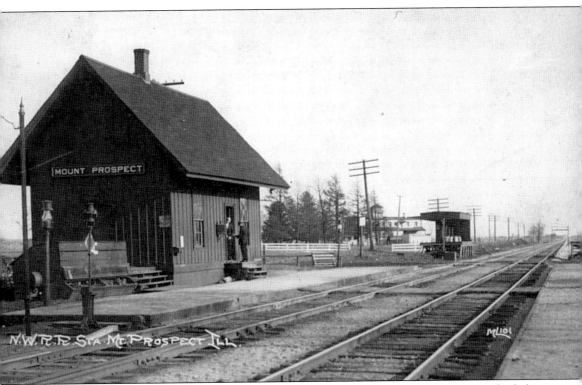

MOUNT PROSPECT DEPOT, C. 1920. The first train station in Mount Prospect was built by Ezra Eggleston as a part of his development scheme. However, long after Eggleston had gone bankrupt and left the community, the train station remained the centerpiece of the community. In this picture you can see the kerosene lanterns used to light the platform and, a few feet past the station, a raised platform with large milk cans that have been dropped off by a train coming out of Chicago and are waiting to be picked up by the local farmers, to be refilled.

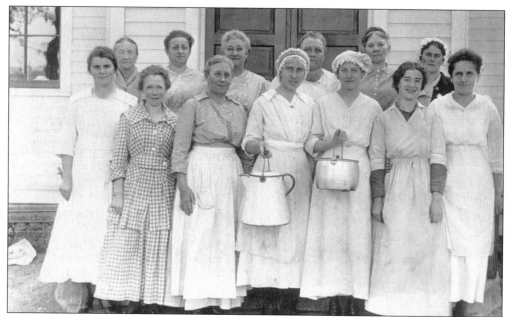

SAINT PAUL'S LADIES AID, C. 1917. This group of women is seen standing in front of the original Central Schoolhouse. The group would get together and cook to help out at the local schools, Central and Saint Paul. Some of the people in this photo are: (front row) Mrs. Sophie (Busse) Mueller, the wife of Saint Paul's pastor; Mrs. Ida (Deeke) Meyn, the wife of Mount Prospect's second mayor, Herman Meyn; and Lena Friedrich, mother of Bessie and wife of Dietrich; (back row) Dina Busse, second wife of Commissioner William Busse; Bertha Ehard, founder of the Campfire Girls in Mount Prospect; and Blanche Rickard, the school teacher.

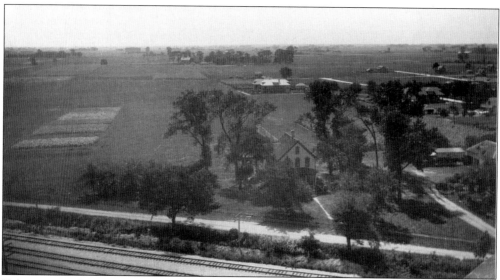

HOME OF THE SPORLEDER FAMILY, C. 1920. The Sporleder family was one of the early German pioneer families in the area. They were involved in the founding of Saint Paul Lutheran Church and a number of other community events. This picture, taken from either a bridge over the Chicago Northwestern tracks or the water tower, shows their home and farm as well as the open agricultural landscape of Mount Prospect at the beginning of the 20th century.

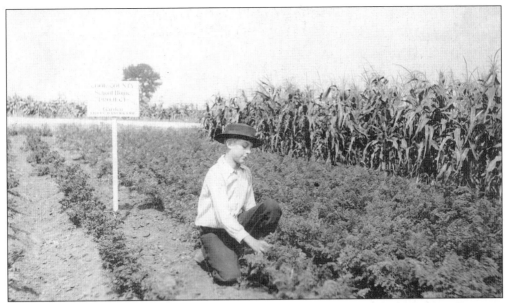

EDWIN HABERKAMP WORKING ON THE COOK COUNTY SCHOOL HOME PROJECT GARDEN, 1920. The Haberkamps were one of the early German families in the area and were deeply involved with the development of Mount Prospect. Edwin Haberkamp later went on to become the first professional fire chief of Mount Prospect. Between working with the volunteer fire department, and being the first professional fireman, he put in 36 years with the Mount Prospect Fire Department.

ALBERT WILLE ADVERTISEMENT, C. 1918. Albert Wille and his brother Louis started a business in coal, feed, salt, brick, and sand in 1902 at the intersection of Northwest Highway, Busse Avenue, and Wille Street. A few years later, Wille Lumber was founded, a business that provided building materials for many of the homes built in town. The Wille family was very involved in the development of Mount Prospect. William Wille, Albert Wille's father, built the Central School, Wille Hall, Wille Tavern, and many houses in town. Albert and his brothers were all involved in the business community and the local politics of Mount Prospect.

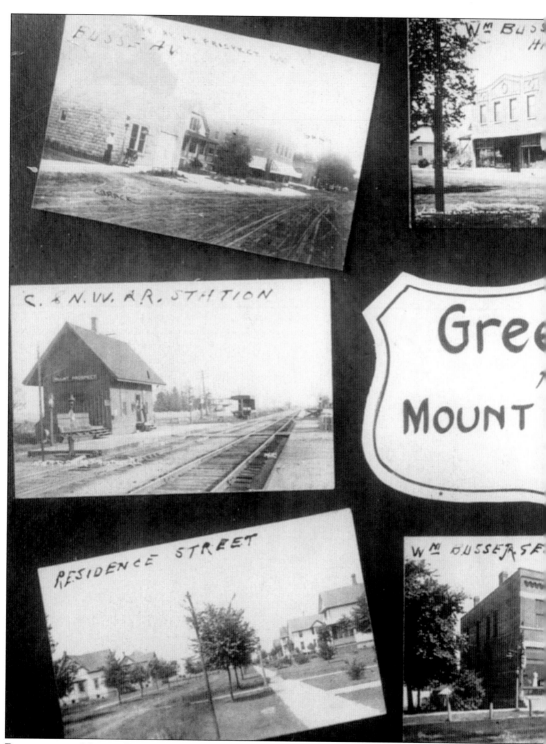

POSTCARD OF MOUNT PROSPECT, C. 1920. This postcard was made to advertise the businesses and property in Mount Prospect. The postcard shows what a person would look for in a community in the 1920s. It had a church, a school, a railroad station, and some businesses. It

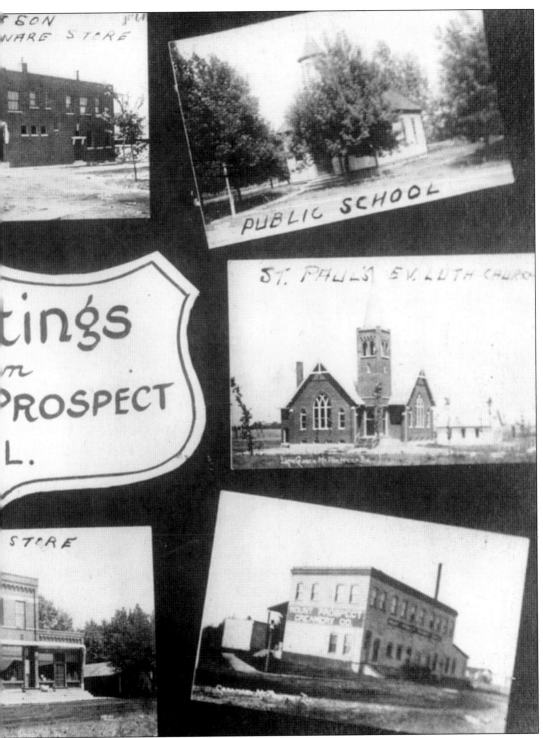

is interesting that all of the businesses on this postcard were owned by the Busse family. The Moehling General store is not seen, nor is Kruse's Tavern, Wille's tavern, or Wille's Lumber. The view of the "Residence Street" (*sic*) is also a part of Busse's Eastern Addition.

MOEHLING STORE, C. 1920. This building housed the first store in Mount Prospect. It was originally started by Cook County Commissioner Christian Geils. However, Geils soon found out that running a general store was not his calling in life. While Geils was discovering that he did not like running a general store, a man named John Conrad Moehling was in Elk Grove discovering that he did not like farming. In 1882, the two came together and Moehling bought the store. He found that he did enjoy being a store keeper and he became an institution in the community. He began selling farm tools, coal, seed, feed, groceries, shoes, etc. Moehling was also appointed the first postmaster of Mount Prospect on December 31, 1885, and based the local post office in his store. According to legend, Moehling was also the person who brought dairy cows to Mount Prospect. Seeing that the area was appropriate for milk cows, he went off in search of the best breed and eventually brought the cows back, kicking off Mount Prospect's role as a major dairy center.

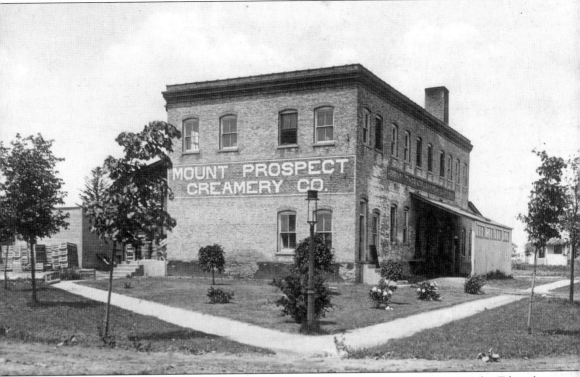

MOUNT PROSPECT CREAMERY COMPANY FACTORY, C. 1920. Founded in 1910 by Edward Busse, the Mount Prospect Creamery quickly became a major distributor of milk, cheese, and butter. This was not the first creamery in Mount Prospect. William Wille had run a much smaller creamery at the end of the 19th century, but he closed it in 1902. In the years after Wille closed his creamery, Mount Prospect became one of the largest producers of dairy products in northern Illinois. The farmers with dairy cows had to ship their milk into the city on the Chicago Northwestern trains each day and pay a charge on each can they shipped. When a creamery opened in Mount Prospect it was cheaper to sell it locally. The Mount Prospect Creamery grew quickly and was soon shipping bottled milk, butter, and cheese all around the Chicago area.

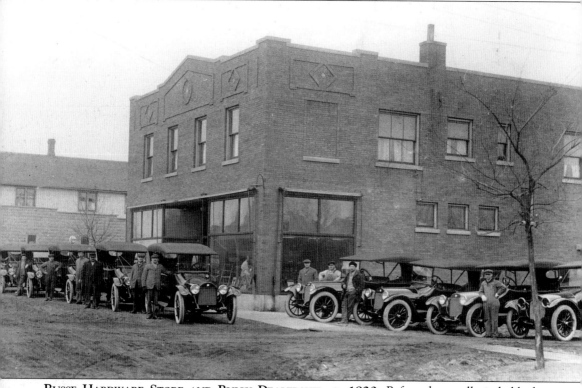

Busse Hardware Store and Buick Dealership, c. 1920. Before the small cinderblock building seen on the left was built in 1915, Busse Buick had no garage. Each morning they would roll the cars out onto the street and then roll them back into the store at night. The cinderblock building was used as a service station, complete with gas pumps; however, it was still too small for their operations. They built a larger building on Main Street, and in 1926 the cinder-block structure was demolished to make way for the Busse Building that stands there today.

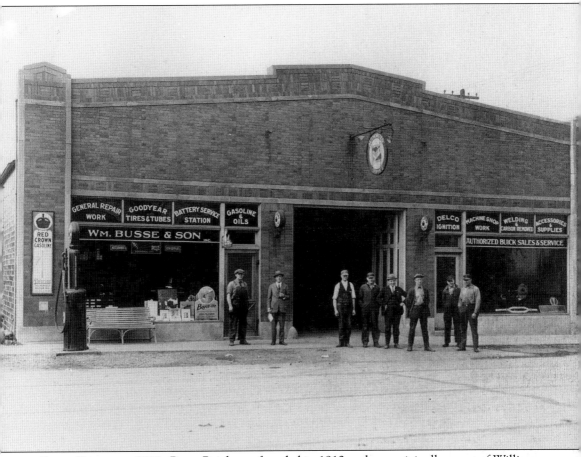

BUSSE BUICK, C. 1921. Busse Buick was founded in 1912 and was originally a part of William Busse's Hardware store. The dealership had no garage, so as a temporary solution in 1915 they built a cinderblock garage where the Busse Building stands today. Then, in 1918, they began construction of this building at 30 South Main Street. The building was expanded in 1921 and then again in 1928. In the same year, William Busse broke up the Busse Hardware Store, making Busse Buick independent. He sold the hardware store to Frank Biermann, creating Busse-Biermann Hardware, and sold the farm equipment dealership to Herman Meyn.

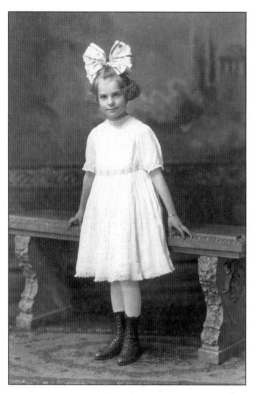

BESSIE FRIEDRICHS, C. 1922. Bessie lived almost her entire life with her parents Dietrich and Lena Friedrichs. Following graduation from high school she married; but instead of moving out of her parent's house, her husband, Fred Linnenkohl, moved in. Fred died very young, a few years after their marriage. Bessie continued to live with her parents, and was married a second time later in life. Her second husband, Charles Barnes, also moved in with her parents.

ORIGINAL BUILDING FOR SAINT PAUL LUTHERAN CHURCH, C. 1920. Distance was difficult before cars, so while downtown Mount Prospect was developing, local leaders and real estate investors made a point of developing services in Mount Prospect's downtown. Saint John Lutheran Church was quite a distance from the center of town so community leaders formed Saint Paul Lutheran Church to provide spiritual leadership closer to home. The congregation was formed in early 1912 and held its first meeting in the Central Schoolhouse. The congregation located a pastor and dedicated the first church building by 1913.

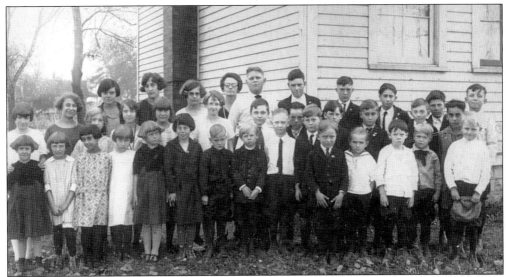

CENTRAL SCHOOL CLASS OF 1923. The Central School was the first public school built in Mount Prospect and was also a center for many community affairs. This was also the only school within the borders of Mount Prospect when it was incorporated. All age groups were seated in the same room. One teacher gave each student assignments and guidance based on their age and where they were in the class work. The teacher's name was Miss Butler, and some of the children were from the Haas, Moehling, Friedrich, Behlendorf, and Katz families.

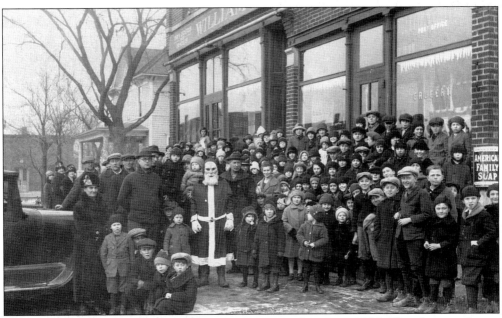

SANTA CLAUS OUTSIDE WILLIAM BUSSE JR. GENERAL STORE, C. 1923. This photograph may very well show every child living in Mount Prospect at the time it was taken. Considering that the population of Mount Prospect was around 350, there could not have been many children who are not in this photo. This store was along Main Street in between Northwest Highway and Busse Avenue. William Busse Jr. is the man with glasses to the left of Santa. William Busse's first house is next door, and the Mount Prospect State Bank is past it in the distance.

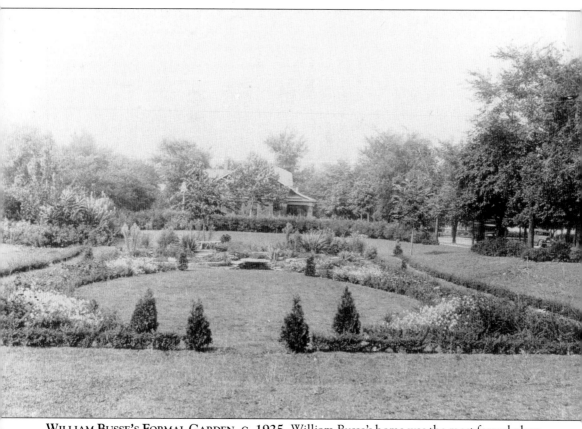

WILLIAM BUSSE'S FORMAL GARDEN, C. 1925. William Busse's home was the most formal place in Mount Prospect. As a Cook County commissioner and the president of the Mount Prospect State Bank he needed a formal spot to entertain visitors. On the block between Main Street and Emerson, along Busse Avenue, he built his house and a sunken garden for entertaining in the warmer months of the year. In the background of this photo you can see William Busse's second house, which was built in the early 1920s.

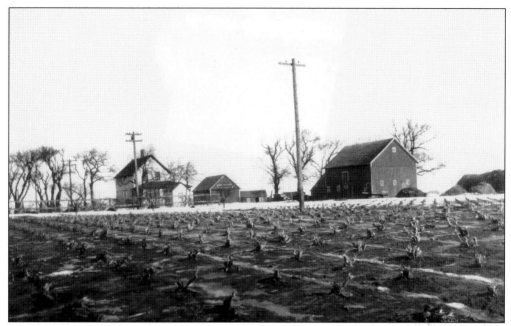

FARM SCENE, C. 1925. This view is from Main Street looking northeast towards Henry Street. You can see the open farmland in the winter, with all the crops cut down. Parts of this area were developed in 1927 as a part of the Laudermilk Villa subdivision, although the entire area was not subdivided until 1957.

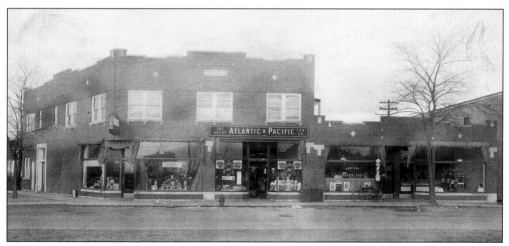

EDWARD BUSSE BUILDING, C. 1926. The Edward Busse Building was built in 1925 and was advertised as "the first genuinely modern building to be erected in Mount Prospect." This building, which is still standing today, sits at the corner of Emerson Street and Northwest Highway. In the 1920s, it housed Hilliard Drug Store, the A & P store, the first dentist's office, and the office of Mount Prospect's first Doctor, Louise Koester. It was unusual that Mount Prospect's first doctor was a woman. At the time, there were very few female physicians in America, and most were in larger cities. Dr. Koester was born in Germany and trained in Chicago. She had planned to do missionary work overseas when she was told about Mount Prospect, a growing community in need of a doctor. After considering it and weighing where she could help more people, she chose to move to Mount Prospect and open an office.

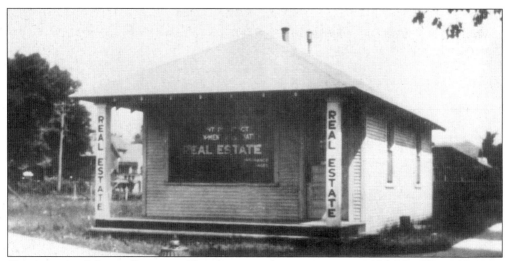

OFFICE OF THE MOUNT PROSPECT DEVELOPMENT ASSOCIATION, C. 1925. The Mount Prospect Development Association was founded in 1923 by George Busse, his brothers, and several friends. The first major project that they undertook was the subdivision of what was left of Owen Rooney's farm, which became known as Busse's Eastern Addition. The association went on to a series of other development projects as the community continued to develop. It was well positioned as Mount Prospect's population began to grow rapidly in the late 1920s. From the 1920s until 1950 the population of Mount Prospect grew by an average of 120 residents a year, which is impressive when you consider that Mount Prospect's population was 349 in 1920. In 1937 the Mount Prospect Development Association was renamed George L. Busse Real Estate, Inc.

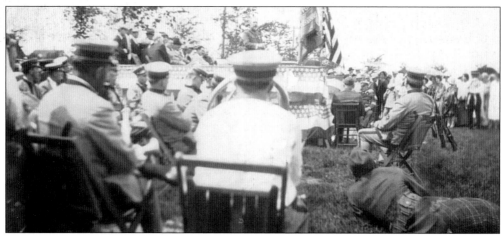

CEREMONY FOR THE CHARTER OF THE MOUNT PROSPECT VFW POST, 1925. A traditionally German community, Mount Prospect was forever changed by World War I. A number of local men joined the U.S. Armed Forces and traveled overseas, while many who remained in Mount Prospect began to suppress their German roots and highlight their American loyalties. Saint John Lutheran Church, the first congregation in Mount Prospect, did all of its services in German until 1923 when it began offering English language services as well. Following WWI, the community became more open to other groups and the population became more diverse. The ceremony seen here was held in Owen Park, just south of Busse Avenue between School and Owen Streets.

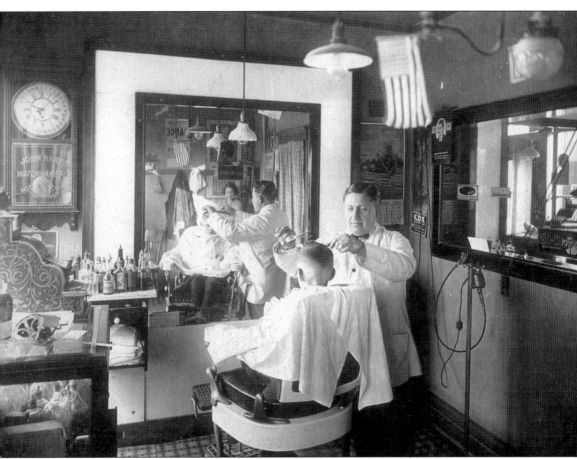

INSIDE BALDINI'S BARBER SHOP, C. 1925. Louie Baldini ran the first professional barbershop in Mount Prospect, although he was not the first barber in the community. During Prohibition, Adolph Wille, who ran Wille's Tavern, turned the bar into Wille's Buffet and expanded his business in a number of directions. In 1922, he was granted the first barber's license for one chair, which was tucked away in the back room of the buffet. Shortly after beginning his career as a barber he built a small shop next door and brought in Louie Baldini to run the shop.

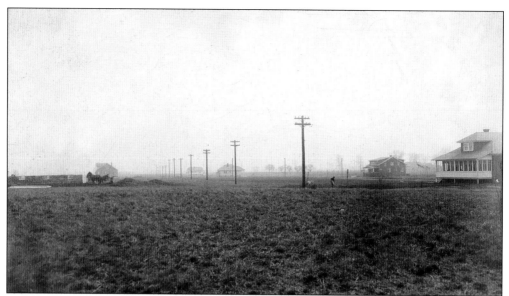

VIEW SOUTHWEST FROM THE CORNER OF BUSSE AVENUE AND EDWARD STREET, 1926.
This photograph shows how open and agricultural the area was in the early 1920s. Busse's
Eastern Addition was soon followed by developments by Axel Lonnquist and H. Roy Berry and
Company. With the rapid development of farmland and aggressive marketing, the population
of Mount Prospect grew over 350 percent between 1920 and 1930, a population boom not
surpassed until much later during the post-WWII suburban expansion.

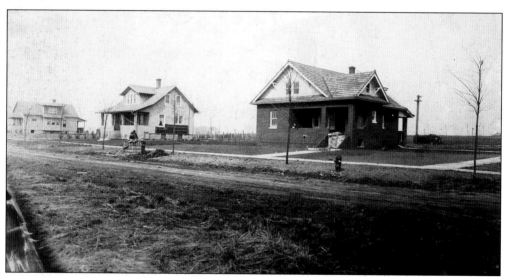

VIEW OF OWEN STREET NORTH OF BUSSE AVENUE, 1926. This photograph shows part of the
subdevelopment known as Busse's Eastern Addition. Following the bankruptcy of Mount Prospect's
first developer, Ezra Eggleston, there was little development in town for over 20 years. In 1905,
William Busse and William Wille re-subdivided the original downtown. However, the boundaries
of the town did not expand until 1923 when George Busse purchased the remaining acres of the
Owen Rooney Farm, formed the Mount Prospect Development Association, and began platting
Busse's Eastern Addition. This subdevelopment doubled the size of Mount Prospect.

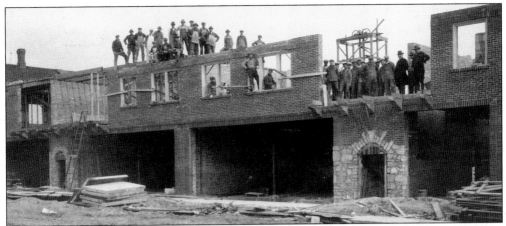

CONSTRUCTION OF BUSSE BUILDING, 1926. William Busse built two very similar buildings at the same time. The buildings were constructed between 1926 and 1927 and by the time they were completed, they had become a dominant part of downtown Mount Prospect. This building was along Busse Avenue and stood between Wille's Tavern and William Busse's Hardware store.

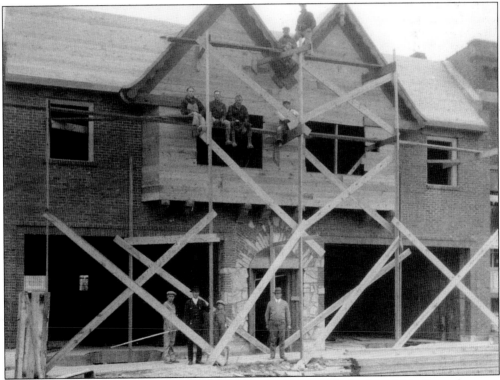

CONSTRUCTION OF BUSSE BUILDING, 1926. This building was built along Main Street between Northwest Highway and Busse Avenue, while an almost identical building was built simultaneously on Busse Ave between Main and Northwest Highway. This building would house the first Meeske's Market, a store that was an institution in the community for 50 years. The man in the dark suit is John Pohlman, one of the village's first trustees, while the man standing directly in front of the door is William Busse Jr. At the edge of the picture you can see a part of William Busse's first house; this house was given to William Busse Jr. soon after this picture was taken.

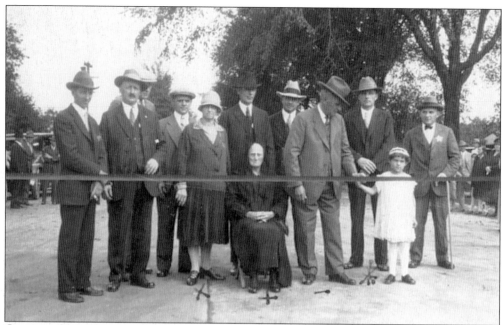

OPENING CEREMONY FOR THE FIRST 25 MILES OF PAVED ROAD IN MOUNT PROSPECT, 1926.
Mount Prospect was developing quickly in the 1920s, thanks, in part, to a couple of people in this picture. The man in grey holding the little girl's hand is William Busse, the mayor at the time and Mount Prospect's biggest promoter. The man in the white hat, behind William Busse, is Axel Lonnquist, a major developer on the south side of town and the founder of the Northwest Hills Country Club, now known as the Mount Prospect Country Club. The little girl was Verna Maleske, and the woman seated was William Busse' Mother, Christine Kirchhoff Busse.

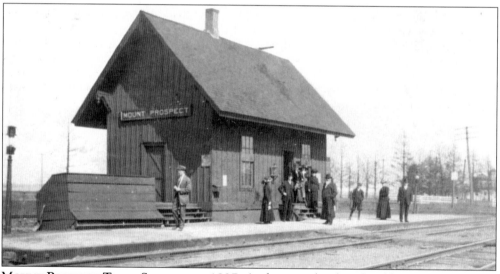

MOUNT PROSPECT TRAIN STATION, C. 1927. As the town developed and began to attract new homeowners, the main cargo that was shipped out of the Mount Prospect depot slowly shifted from dairy products and farm goods to commuters. By the 1940s, the number of commuters would outnumber the milk cans, and by the end of the 1950s there would be no more milk cans going into Chicago.

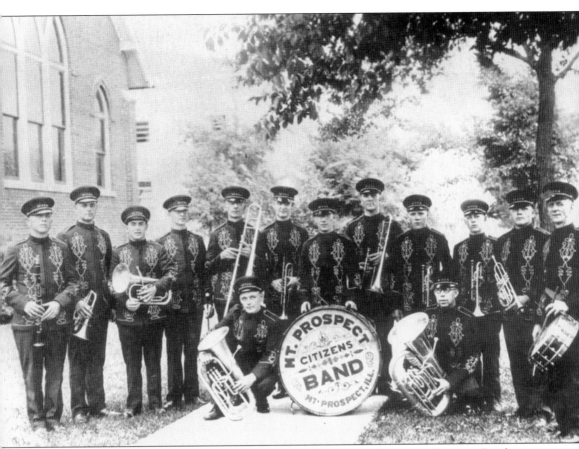

MOUNT PROSPECT CITIZENS BAND, C. 1927. The Mount Prospect Citizens Band was formed in January of 1927. Many small community organizations began to develop as Mount Prospect's population increased. This helped people be social, meet new neighbors, and provide entertainment for themselves and the community. The constitution of the Mount Prospect Citizens Band stated: "The objectives of this Band are educational, to further the interests of music among its members, and to furnish a means of entertainment for this community in such a manner as its By-laws may provide."

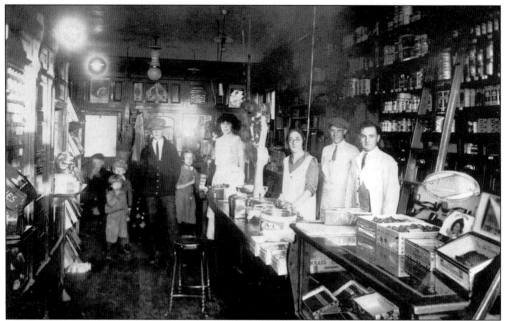

MEESKE'S MARKET, C. 1927. The first Meeske's Market was established in the building along Main Street built by William Busse in 1926. Busse wanted to bring in a grocery, because he thought that would help the town grow. This market was much smaller than the grocery stores we know today, but, at the time, it was a real advancement for the community. Later, William Busse moved his first house to open up land for commercial use and built a new building that became the second Meeske's Market on the corner of Busse Avenue and Main Street; it is a bakery today.

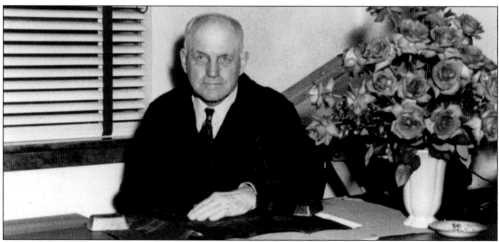

WILLIAM MULSO, 1949. In 1924, the Village of Mount Prospect hired William Mulso as the first police chief in Mount Prospect. He replaced a magistrate as the head of law enforcement in the community. He was, in fact, a one man police and public works department. When he took the job, there were no paved roads and the population was less than 500. The town developed quickly in the 1920s, and in 1932 he hired George Whittenberg as a second police officer, in part because Whittenberg was able to ride a motorcycle. With the help of a portable jail cell, known as the Blaha after its first occupant, the two kept order in the community. In this picture Mulso is seen with 25 red roses honoring his 25th anniversary with the village.

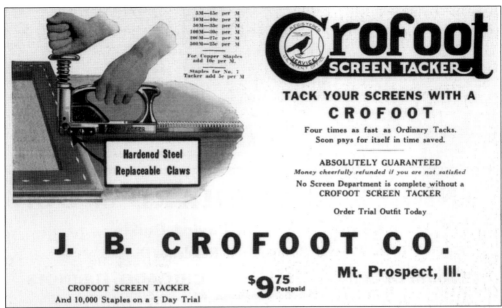

CROWFOOT ADVERTISEMENT, 1927. The Crowfoot Company was probably the largest industrial concern in Mount Prospect in the 1920s. The factory produced "modern and up-to-date" staplers and tackers for a number of uses, including assembling screens and attaching labels to shipping crates. Originally started in 1905 in the Crowfoot family home in Milwaukee, it moved to Chicago to take advantage of the larger market and the easy access to transportation. The firm moved to Arlington Heights in the early 1920s, but was lured to Mount Prospect by William Busse a few years later. The factory was located in a large building on the corner of Evergreen and Maple, near the water tower.

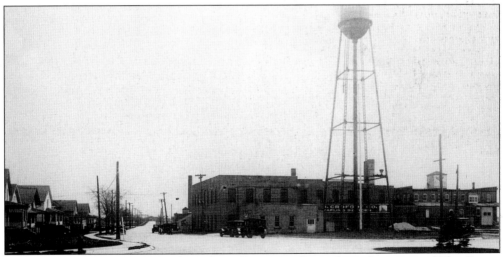

DOWNTOWN SCENE, 1927. Looking down Evergreen Street from the corner of Elm Street, you can see the Crowfoot Factory, the original water tower, and some examples of the new homes in Busse's Eastern Addition. You can see the relatively new telephone poles that extend well beyond the line of houses. In the 1920s, when the Crowfoot Company moved to Mount Prospect, it brought a workforce that was looking for homes and it greatly increased the population of the community.

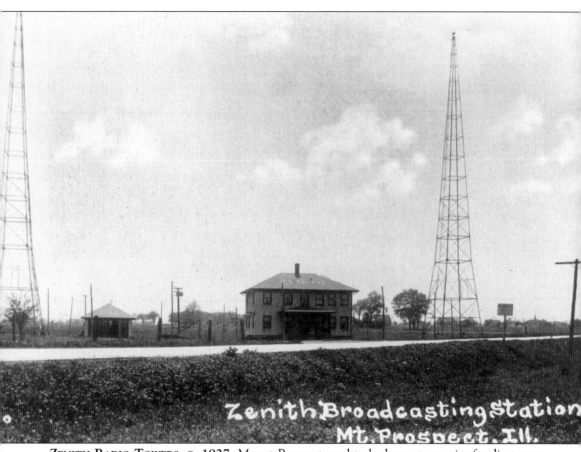

ZENITH RADIO TOWERS, C. 1927. Mount Prospect used to be home to a pair of radio towers and an early broadcasting station. The Zenith Towers were located at the corner of Central Road and Rand and operated from 1924 through the 1970s. Zenith built the towers in Mount Prospect to broadcast into Chicago and to all the farmers and small towns northwest of the city. Much of early broadcast radio was done live, and this station was no different. Bands would come out to the station from Chicago and around the country to play in the broadcasting station. Some very famous musicians from the big band era played in Mount Prospect. For years these towers were the tallest things in Mount Prospect and could be seen for miles.

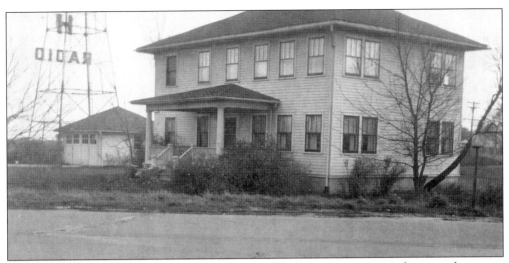

ZENITH BROADCAST STATION, C. 1927. The small broadcasting station in between the towers was also the home of the Zenith employee that ran the station. Gilbert Gustafson was the first station manager for WJAZ. He lived in the station with his family from around 1925 to 1935. In the 1920s, radio was in its infancy. Because this area was still mostly farms and there were only a few radio stations broadcasting, there was little interference and on a clear day you could pick up radio stations from hundreds of miles away. Unfortunately, because the radio signals were much weaker, on a day with wind, rain, or clouds you could only pick up the most local stations.

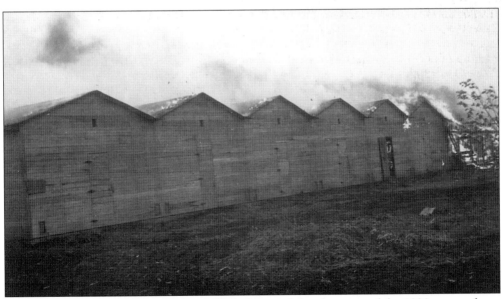

BURNING OF ONION SHEDS, C. 1927. With the rapid development of the 1920s, many farms were subdivided into residential lots and many of the drying sheds downtown were demolished to make way for commercial development. As was common in relatively undeveloped areas, many of the buildings were simply burned, since this was a cheaper way of removing them.

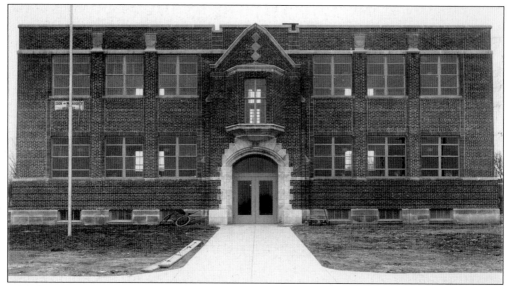

THE SECOND CENTRAL SCHOOL, 1927. As the community grew, it became clear that the village had grown too large for a one-room school. In 1927, the second Central School, later known as the Central Standard School, was constructed. This new building had four rooms and was built facing Emerson Street right next to the original Central School. The building had a number of additions built onto it over the years and was eventually demolished in 1975.

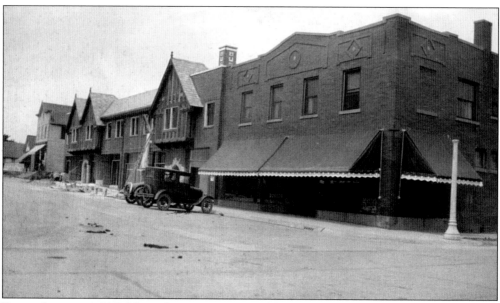

BUSSE AVENUE, 1927. Mount Prospect was a quickly developing town in the 1920s. Here you can see William Busse's Hardware Store on the corner, the final stages of the construction of the Busse building, and Wille's Tavern. Directly past Wille's Tavern you can see the tip of a smaller building. This was Baldini's barber shop, which was built in the early 1920s and was the first barber shop in Mount Prospect. However, the building originally stood on the other side of Wille's Tavern, and was moved because of a land dispute within the Wille family.

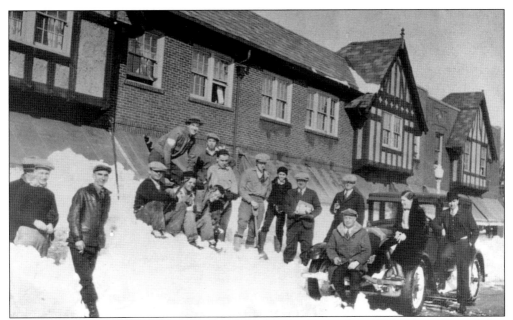

Busse Avenue after Blizzard, 1928. At the end of December 1928, a huge blizzard shut down much of the Chicago area. In small semi-rural communities like Mount Prospect, they would only plow the major streets downtown. Most of the roads in the community would be gone over with a large roller that was dragged by a team of horses. This would pack the snow down and create a flat smooth surface upon which people could walk or use horse-drawn sleds.

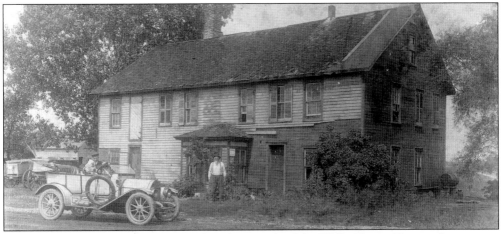

Wille Cheese Factory, c. 1928. This photograph of the Wille Cheese Factory shows it just a few days before it was demolished. Founded in 1880 by William Wille, the Cheese Factory operated for over 20 years at the corner of Northwest Highway and Wille Street. Wille would buy milk from local farmers, turn the milk into cheese and butter and then take wagonloads of cheese and butter to Chicago for sale. In a 1977 interview, William's son, Adolph, remembered going to Chicago with his father in the spring when the roads were muddy. He recounted how the wagon would get stuck in the mud and the cheese and butter would have to be taken off, the wagon freed and then all the cargo reloaded. After years of doing this, William Wille got tired of the hassle and closed the factory in 1902. The building was demolished in 1928 when Northwest Highway was widened.

MAYOR HERMAN MEYN, 1929. Soon after Herman Meyn was sworn in as Mount Prospect's second mayor, the U.S. entered the Great Depression. Meyn stayed mayor through the entire crisis. During that time, Mount Prospect became known as one of the most responsibly run communities in Illinois. It was one of very few communities in the area that remained solvent throughout the 1930s.

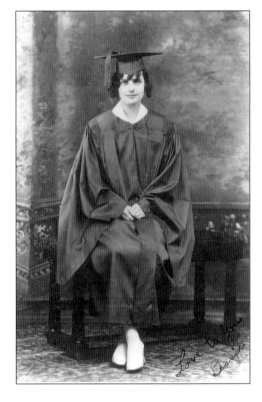

BESSIE FRIEDRICHS HIGH SCHOOL GRADUATION PICTURE, 1929. Bessie lived almost her entire life with her parents Dietrich and Lena Friedrichs. By today's standards, this does not sound very empowering, but Bessie was more independent than it may appear. She graduated from a four-year academic high school, which was unusual for anyone in Mount Prospect at the time, but was exceptional for a woman. She also did it without the support of her father, who did not believe that women needed to be educated. Since there was no high school in Mount Prospect, she had to travel to Arlington Heights to go to class. She also worked as a professional for years, which was quite independent for the time.

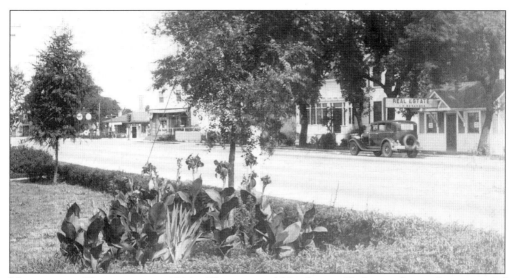

NORTHWEST HIGHWAY, C. 1930. This view of Northwest Highway shows the center of downtown Mount Prospect at the start of the Great Depression. The real estate office on the corner belonged to Inge E. Besander, Mount Prospect's third mayor. He was a developer in the area and became mayor in 1937. He remained in office through the Second World War and retired in 1945. A little farther down the road you can see the Moehling General Store and across the street, the Moehling Gas Station.

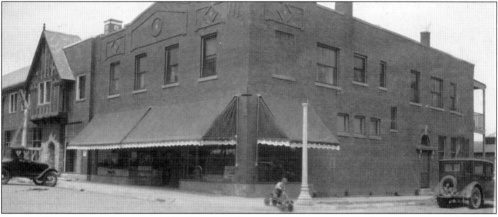

BUSSE HARDWARE STORE, 1927. The building on the corner with the awnings was built in 1912 and was the home of William Busse's hardware store. The building was also the home of Busse Buick, the first car dealership in Mount Prospect. The story of the birth of Busse Buick starts in 1908. In that year, William Busse was walking along Michigan Avenue in Chicago with a business associate when they passed a Buick dealership and were fascinated by the car they saw in the window. They were a little cautious, but agreed to go into it together and bought a car. William Busse enjoyed the car and two years later upgraded to a car with a larger engine. He was so impressed that he contacted the manufacturer and offered to become a local agent. He was told that dealers in Chicago had an agreement covering all of Cook County, so it was not possible. Two years later, when he was finishing the roof of this building, a stranger climbed up the ladder and asked to speak to William Busse. He explained that he was a Buick representative and had come to offer Busse a charter for a local agency. Busse jumped at the chance, signed the papers while still on the roof, and Busse Buick was born.

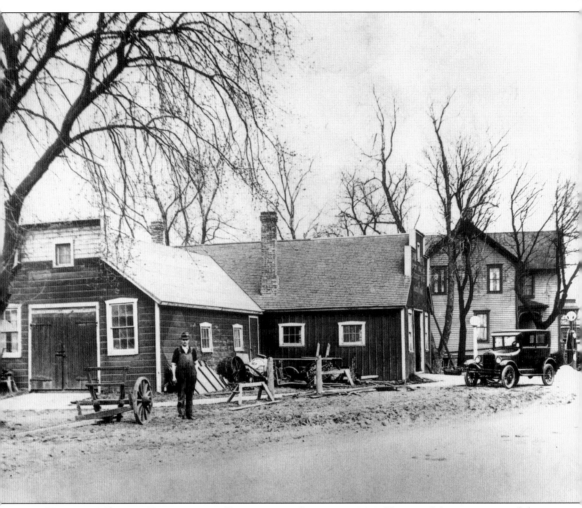

HERMAN MEYN IN FRONT OF HIS BLACKSMITH SHOP, C. 1930. Herman Meyn was one of the sons of John Meyn, Mount Prospect's first blacksmith. Herman followed in his father's footsteps and became a blacksmith, but he also had larger plans in life. Herman extended the business. He brought in a gas pump, creating one of Mount Prospect's first gas stations. Then, in 1929, William Busse split up his business on Busse Avenue by forming Busse Buick, Busse-Biermann Hardware, and by selling his International Harvester implement dealership to Herman Meyn. In the same year, Herman Meyn was elected as Mount Prospect's second mayor. He was mayor through most of the Great Depression and kept the community on a stable course through difficult times. Herman also served as fire chief for years and was active in all aspects of community life.

BOTH CENTRAL SCHOOLS NEXT TO EACH OTHER, C. 1930. This photograph shows both of the Mount Prospect Central Schools in their original locations. The second Central School was built in 1927 to house the increasing number of students in the growing community. When the second Central School opened, the original Central School became the first kindergarten in Mount Prospect and continued to be a social hub in the community. In 1927, it held the first meeting of the Mount Prospect Woman's Club and then, in 1930, held the first Mount Prospect Public Library. Later, in the 1930s, it housed Mount Prospect's first movie screen and was a community center until 1937, when it was sold to Saint John Episcopal Church and moved to the corner of Wille and Thayer Streets.

ONION SHED ON PINE STREET, 1930. Mount Prospect has a long agricultural history. The community originally developed because of the fertile soil of the upper Midwest and the low land prices for settlers in the 19th century. When the Chicago Northwestern Railroad station was built in Mount Prospect in 1874, the downtown became a center for local farmers who would ship their produce to Chicago. The farmers typically grew onions, sugar beets, and mushrooms and raised dairy cows. Drying sheds like these were built downtown along Northwest Highway to store the onions while they awaited shipment into the city for sale.

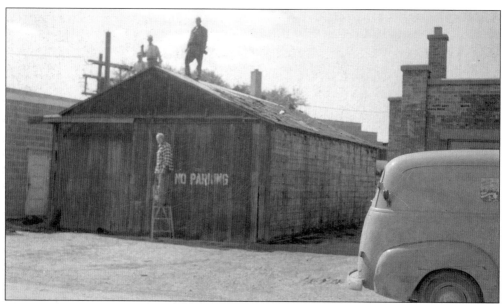

ONION SHED, C. 1930. As the downtown developed a number of the onion sheds were converted to other uses. Stores used the sheds as storage space and individuals used them as garages. With the shifting use of land and the movement away from an agricultural base, most of these buildings were drastically changed, neglected, or demolished. Because these sheds were remnants of an agricultural past that most of downtown Mount Prospect was trying to leave behind, there are few pictures and no remnants left from the buildings that were once a common sight in the community.

Three

EXPLOSIVE GROWTH

FROM THE GREAT DEPRESSION THROUGH POST-WAR SUBURBAN BOOM, 1930–1960

Like all of America, Mount Prospect tightened its belt and got through the Great Depression and then World War II. Development slowed to a halt. But because of the cautious nature of the community, Mount Prospect had not overdeveloped or been risky with the community's finances and was able to weather the storm. Following the end of World War II, the community expanded explosively. Nationally, America saw a huge increase in suburban developments and the baby boom in this time, and Mount Prospect reflected these trends clearly. There were new schools built almost every year, and the population increased from around 1,200 in 1930 to around 18,000 in 1960.

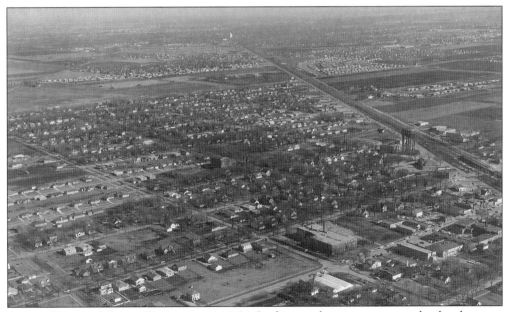

AERIAL VIEW OF MOUNT PROSPECT, C. 1956. In this aerial view you can see the development of Mount Prospect, as well as the remaining open land around downtown. The largest building you can see, toward the center of the photo, is the second Central School. You can see two sets of greenhouses, as Mount Prospect remained a large producer of flowers long after most of the farms were gone. At the right hand side of the picture is most of downtown Mount Prospect. Many of these buildings are still standing.

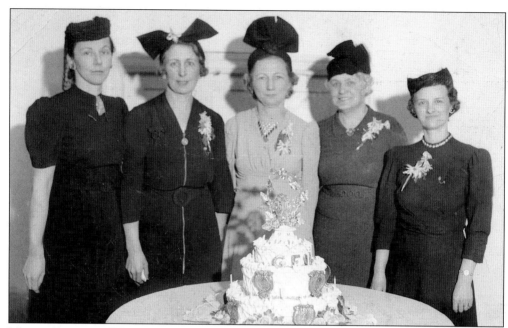

MOUNT PROSPECT WOMAN'S CLUB, C. 1930. The Mount Prospect Woman's Club was founded in 1927 as a service organization focused on improving the community, and the organization has been successfully doing that for the past 75 years. The Mount Prospect Public Library is probably their most famous contribution to the community, although they have assisted many other organizations as well. In this photograph, from left to right, are members Mrs. Sandler, Mrs. Hauptly, Mrs. Ivers, Mrs. Pankonin, and Mrs. Gallagher.

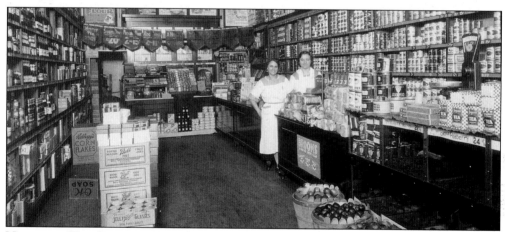

NATIONAL TEA STORE, 1933. This store was located at 115 South Main Street, or inside the Busse building on Main Street. For many years this store was one of the major sources for food and specialty items in Mount Prospect. Before the growth of huge supermarkets along the outskirts of town, people purchased all of their goods in small, locally owned shops like this one. Notice the stacks of Ball jars on the floor to the left. One difference between then and now was that there were no fresh fruits or vegetables in the winter in a small town like Mount Prospect. Families would buy large quantities of fruits and vegetables at farmers markets in the summer and fall and then preserve them in masonry jars, such as the ones seen here, as jams, preserves, or pickled vegetables. The two women in the photo are Lillian Metz and Gussy Maleske.

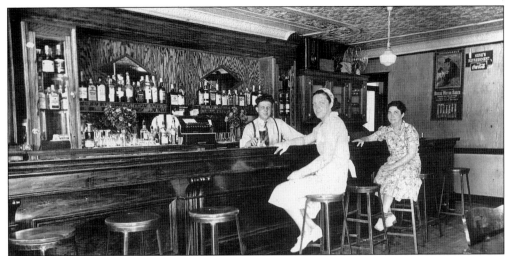

KRUSE'S TAVERN, 1933. Around the turn of the century a man named Henry Behrens bought land right across the railroad tracks from what was downtown Mount Prospect. He built a small frame building and opened a tavern on the first floor. It is hard to say whether Behrens' Tavern or Wille's Tavern was actually the first restaurant in Mount Prospect, but they were both built soon after Mount Prospect became a community. Behrens ran the tavern for almost 20 years, switching to a sandwich shop in 1920 with the passage of the 18th Amendment, or Prohibition. He sold the building and business to the Kruse family in 1923. They soon became an institution in the community. In 1933, with the repeal of Prohibition, Henry Kruse remodeled the space and turned it back into a tavern. In this picture, which must have been taken soon after the remodeling, Henry Kruse stands behind the bar and Sophie Mulso and Alvira Kruse sit at the bar.

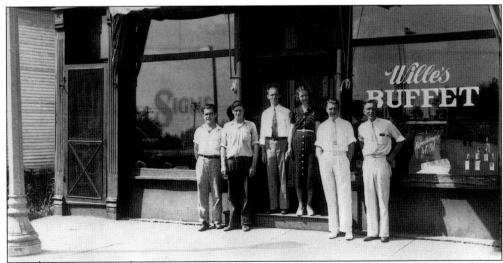

WILLE'S BUFFET, 1933. Wille's Tavern had been founded many years earlier, but with Prohibition the store became Wille's Buffet. This photo was taken in 1933, the year that Prohibition was repealed, and the sign advertising Blatz Beer seems to suggest that the Wille Buffet embraced the transition. The two people standing in the doorway are Adolph and Velda Wille, the owners of the store. They were married in 1917, the same year that Mount Prospect was incorporated, and both lived to celebrate their 65th wedding anniversary in 1982. Adolph also continued to work in this business, pouring beer and serving sandwiches into his 90s.

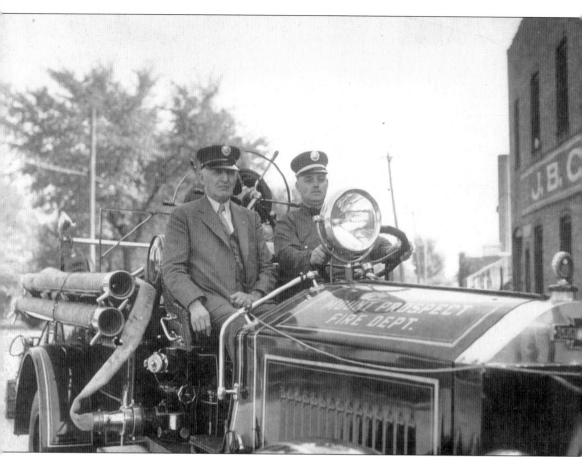

WILLIAM BUSSE AND HERMAN MEYN ON FIRE ENGINE, 1935. The first and second mayors of Mount Prospect are seen here on the volunteer fire department's American LaFrance pumper. Between the two of them, they held the top elected office in the village for 20 years, or from 1917 to 1937. The mayor's office, the fire department, and the village certainly changed in those turbulent years. The village went from a small rural community to a roaring 1920s town to a town struggling to remain solvent during the Great Depression.

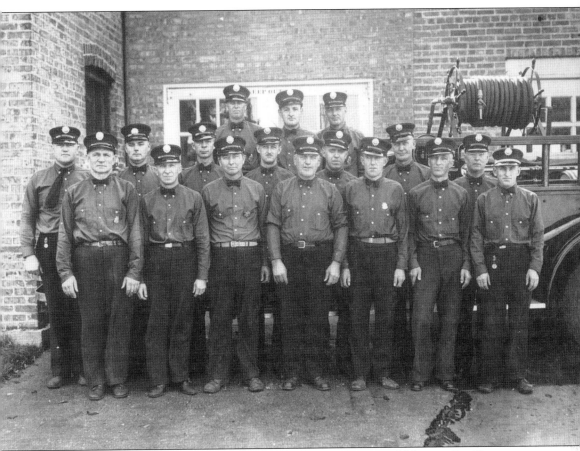

MOUNT PROSPECT FIRE DEPARTMENT, 1935. The Mount Prospect Volunteer Fire Department is seen here in uniform. This picture was taken about 11 years before the public safety building was constructed and the on-call firefighters began to receive a salary. It was not until 1960 that the first two paid, full-time firefighters were hired. Over the years the department has continued to grow and develop. It is now a state-of-the-art department, with three firehouses, public information programs, hazardous material teams, and collaborative projects with other towns.

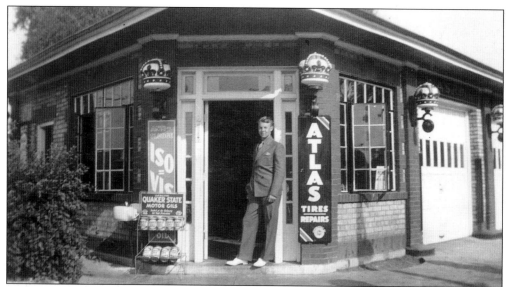

John P. Moehling Jr. Outside of The Moehling Service Station, c. 1934. This service station was one of the first in Mount Prospect. It was built by John C. Moehling, the owner of Mount Prospect's General Store, in 1927. Moehling was always good at seeing trends and anticipating people's needs, so when cars started to become more common, he built a station to service them. His son, seen here in this picture, took over the service station in the early 1930s.

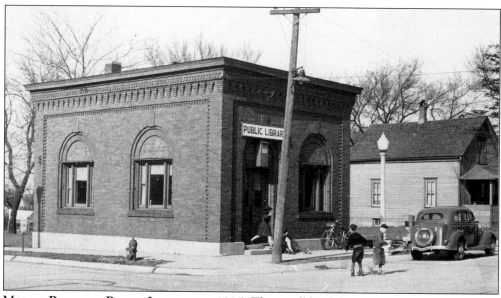

Mount Prospect Public Library, c. 1935. This small brick building stood at the corner of Busse and Main Street. It was built to be the home of the Mount Prospect State Bank, and the bank operated out of this building from 1911 until 1928. The building then stood empty for a couple of years until 1930, when it became the home of the Mount Prospect Public Library. The library had been founded a couple of months earlier in the Central Schoolhouse, which was a couple of blocks away. However, the library quickly outgrew the space and needed its own building. It was able to rent this building for $10 a year and stayed in this little brick cube until 1944. The building was eventually demolished to make a parking lot.

FRANK BIERMANN AND JOHN POHLMAN, C. 1935. Biermann and Pohlman were two of the most civic-minded people in Mount Prospect. They were both members of the volunteer fire department, with Biermann being the fire chief for 26 years. John Pohlman was a member of the first board of trustees in the village and the first stationmaster for the Chicago Northwestern Railroad in Mount Prospect. They served the community for many years, in both official roles and as examples of the welcoming people who gave Mount Prospect a small town feel.

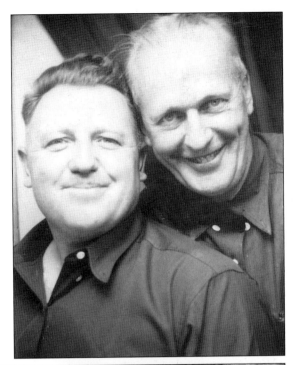

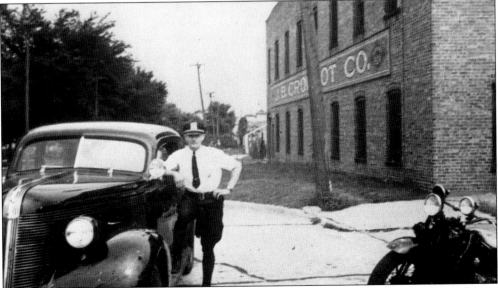

GEORGE WHITTENBERG NEXT TO THE CROWFOOT COMPANY FACTORY, C. 1933. George Whittenberg was the second police officer in Mount Prospect and the second chief of police. He was hired by William Mulso, Mount Prospect's first police chief, who was also the entire police force from 1924 until he hired Whittenberg in 1932. Five years later Whittenberg became the chief of police, a position he held until he retired in 1965. Whittenberg was originally hired, in part, because he could ride a motorcycle and the police department had one motorcycle and one 1929 Pontiac, both seen in this picture. When he took the job, there were no paved roads and the population was about 1,200. By the time he retired, the population was over 25,000, Mount Prospect was twice as large, and the police force had grown from two officers to close to thirty.

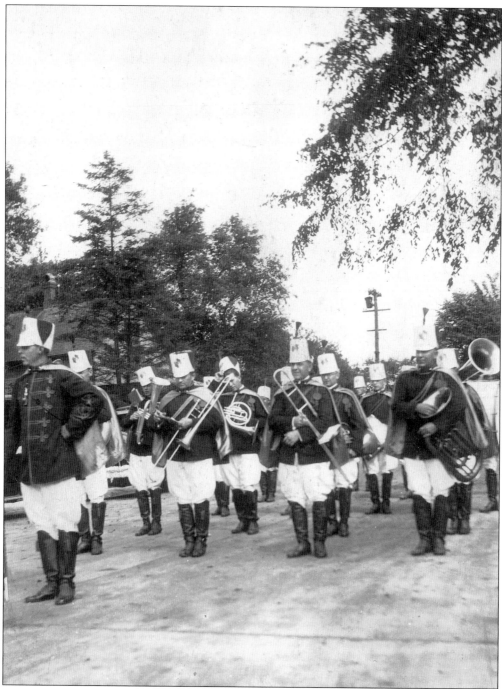

MOUNT PROSPECT CITIZENS BAND, C. 1935. The local marching band is seen here as it marched in a Fourth of July parade. The Mount Prospect Citizens Band was first organized in 1927, but it became more popular as the Great Depression wore on, because people became increasingly interested in local organizations that could provide entertainment and a hobby for people's spare time. Herbert Bernreuter, the band leader, is marching in front as they pass Busse-Biermann Hardware on Main Street.

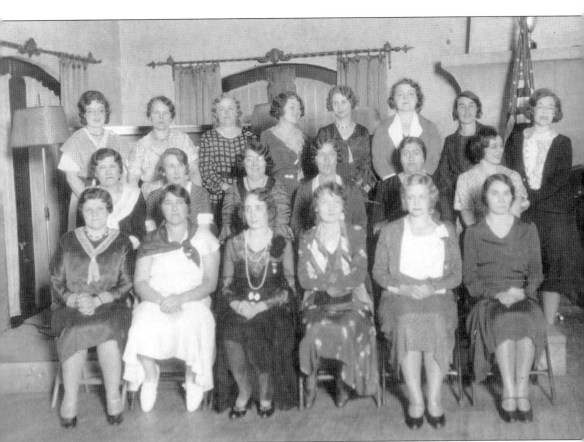

American Legion Auxiliary, c. 1935. In the 1930s, many clubs and organizations developed in Mount Prospect as a source of entertainment during the lean years of the Great Depression. This image shows the Women's Auxiliary of the American Legion, posing at the Mount Prospect Country Club. Axel Lonnquist developed the golf course, originally called the Northwest Hills Country Club, in 1926, as a promotion for his new luxury subdivision. He built the clubhouse in 1929 and laid the first paved streets in Mount Prospect. Unfortunately, two years later national economic trends caught up with him and he went bankrupt.

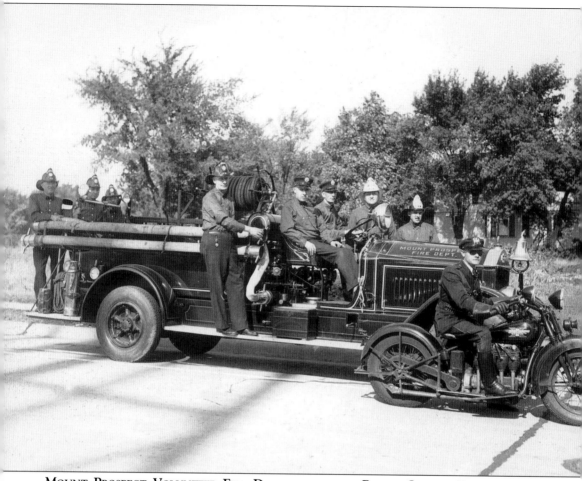

MOUNT PROSPECT VOLUNTEER FIRE DEPARTMENT AND POLICE OFFICER WHITTENBERG, 1935. This picture shows a large part of the Mount Prospect municipal government in the 1930s. The fire department was volunteer, with around 20 members, and the police force was made up of two people. In this picture, George Whittenberg is on the motorcycle, Richard Busse is driving the fire truck, Fred C. Busse is the passenger, John Pohlman is on the side, and Frank Biermann and John Bencic are on the far side.

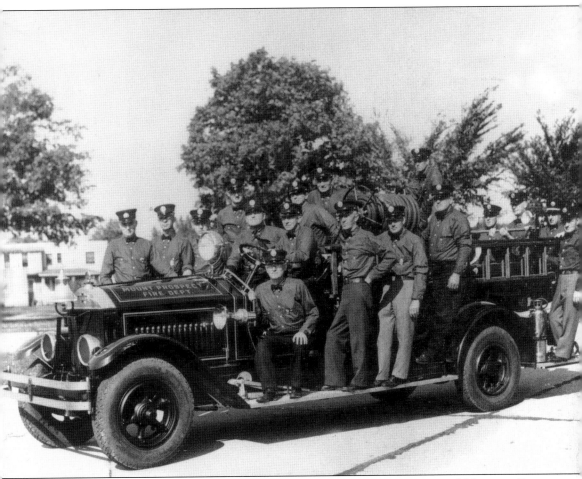

MOUNT PROSPECT VOLUNTEER FIREMEN, 1935. The Mount Prospect Volunteer Fire Department was formed in 1913, four years before the village was incorporated. They originally had very basic equipment—buckets, a couple of ladders, axes, and two pikes. In 1929, the department was able to purchase a fire truck, an American LaFrance pumper, seen in this picture. From left to right, starting in the back, are: Herman Meyn, Edwin Haberkamp, Fred C. Busse, Alvin Beigel, Frank Biermann, Fred W. Busse, Amos Landmeier, Paul Holste, Emil Grienke, John Pohlman, John Bencic, Tony Bencic, and in the front William Busse Jr, Edward Busse, Richard Busse, Dudley Budlong, and William Mulso.

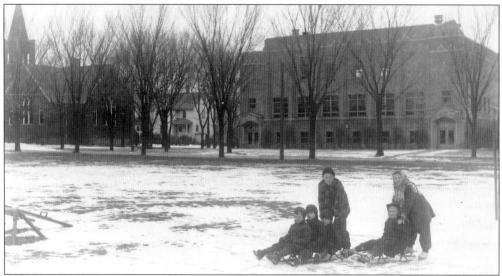

CHILDREN PLAYING OUTSIDE SAINT PAUL LUTHERAN CHURCH AND SCHOOL, C. 1935. Saint Paul Lutheran School was established by Rev. J.E.A. Mueller one week after he gave the first sermon at the church in 1913. School was originally held in a cottage on Main Street, but within a few months it moved to a one-room frame building next to the church. In 1917, as the congregation grew, they were able to hire Martin Hasz as the first full time schoolteacher and allow Reverend Mueller to focus on church matters. The school continued to grow, and in both 1920 and 1921 frame buildings were purchased and moved onto the church lot to house additional classes. The school seen in this picture was built in 1928 and served as the home of Saint Paul School until 1957 when a new building was constructed. It continued to be used in the years following for some classes, until it was demolished in 1989 to make way for an addition.

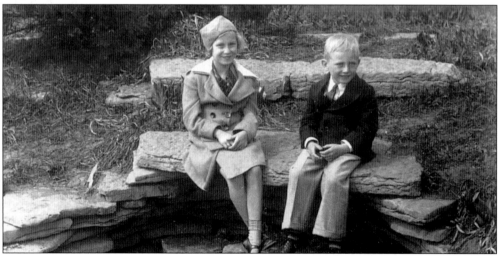

HARRIET AND ALBERT JUHNKE JR. IN WILLIAM BUSSE'S GARDEN, 1937. The Juhnke family had lived in the Mount Prospect area for a number of generations. They, like many of the families in the area, were originally from Germany and came to the area to be near other German families. William Busse, being one of the most important and well connected people in the community, certainly would have known the family. He may have allowed them to use his formal garden for a picture, or they may have just been visiting when this picture was taken.

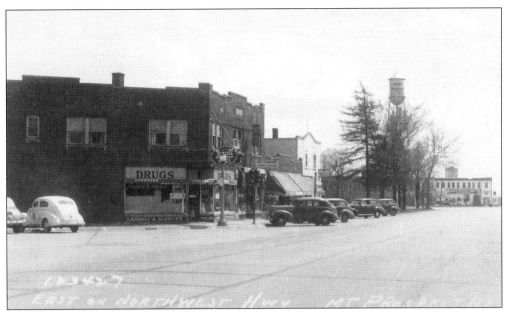

INTERSECTION OF NORTHWEST HIGHWAY AND EMERSON, C. 1936. This was one of the main intersections of a bustling small town. The drug store was on the corner and right past it was the Sanitary Barber Shop and the Sanitary Restaurant, which offered you "Home Cooking." In the distance you can see the first water tower and the building that once housed the Crowfoot Manufacturing Company.

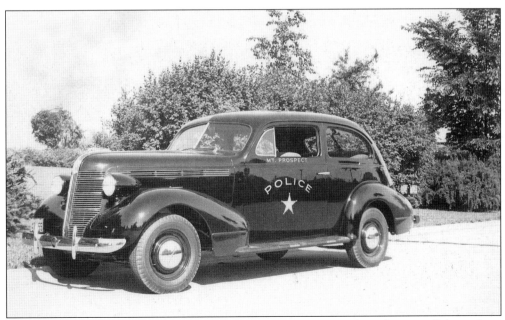

NEW POLICE CAR, 1937. The police force in Mount Prospect may have been small, but at least they had fashionable cars. This picture was taken in 1937, the year that George Whittenberg became the second police chief. He served in this position for the next 28 years, watching the village and the style of the police cars change dramatically.

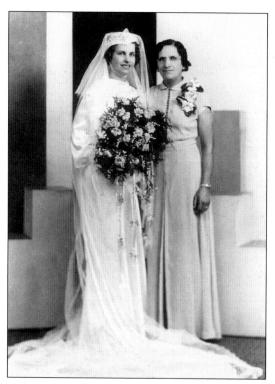

BESSIE AND LENA FRIEDRICH ON BESSIE'S WEDDING DAY, 1937. In many ways, Bessie Friedrich's life demonstrates the transitions that Mount Prospect was going through during the first half of the 20th century. She was born to a couple who had both been born and raised in America by traditional German farming families. Bessie's parents, however, decided to follow a different path, moving into the town of Mount Prospect and having a small family, which Dietrich supported through his house painting business. Bessie grew up in this family and later went on to attend a college preparatory high school, then worked for the telephone company. Her life and her family show Mount Prospect's transition from a traditional German farming community to a more developed town, and finally towards a modern suburb.

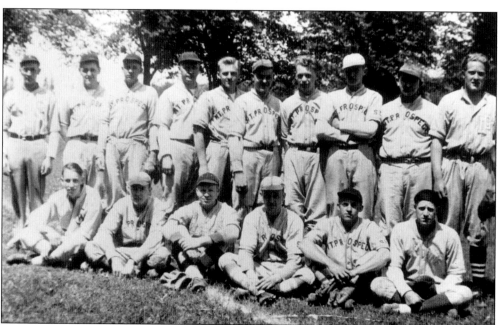

MOUNT PROSPECT BASEBALL TEAM, C. 1938. During the Great Depression, residents in Mount Prospect found a number of ways to entertain themselves without a lot of money. One thing they did was organize sports teams to play teams from other towns. Baseball was quite popular in Mount Prospect. Just a few years after the end of World War II, the Mount Prospect Baseball Association was founded to organize teams in the rapidly growing community.

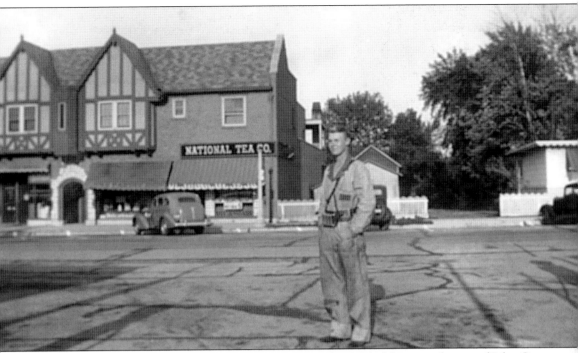

JOHN P. MOEHLING JR. ON MAIN STREET, C. 1938. John P. Moehling was the son of John C. Moehling, the owner of the general store (Mount Prospect's first business). John P. was also a businessman in Mount Prospect, running a gas station on the corner of Main and Northwest Highway, which might explain the coveralls he is wearing in this photograph. Here you can see the National Tea Store, which was located inside the Busse Building on Main Street

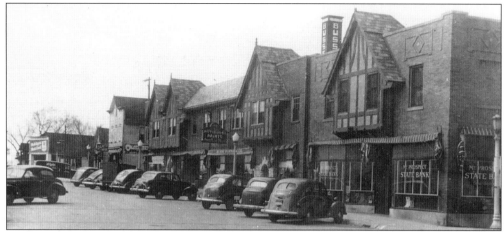

BUSSE AVENUE LOOKING WEST, C. 1938. Busse Avenue was the center of the business district in Mount Prospect. However, in the 1930s business was not booming. In many ways Mount Prospect fared better than most communities. Mayor Herman Meyn oversaw a municipal government that never went bankrupt and never stopped offering basic services. The Mount Prospect State Bank, seen here on the corner, remained solvent throughout the Depression with uninterrupted service. The only time it closed its doors was for 10 days in 1933 when President Roosevelt ordered all banks to close and sort out their books. The Mount Prospect State Bank moved into this building on the corner in 1928 and weathered the Great Depression from this location. The bank stayed in this location from 1928 through 1967, when they built the building on Busse and Emerson that later became Village Hall. Next door to the bank is the Busse-Biermann Hardware, and past that is Wille's Tavern.

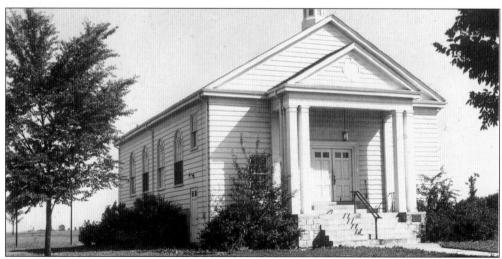

SOUTH CHURCH, C. 1938. Mount Prospect was originally a German Lutheran farming village, but with the rapid development of the town in the 1920s, the community began attracting many different groups. Saint Paul was more inviting to the new residents, as it offered services in English, while Saint John Lutheran, the first church in Mount Prospect, was still all in German. As the community grew, the demand for a non-Lutheran church also grew. In 1935, a group of 13 men and women met and began what would eventually become South Church, the first non-Lutheran church in Mount Prospect. The first pastor arrived in 1937 and the church was dedicated in 1938.

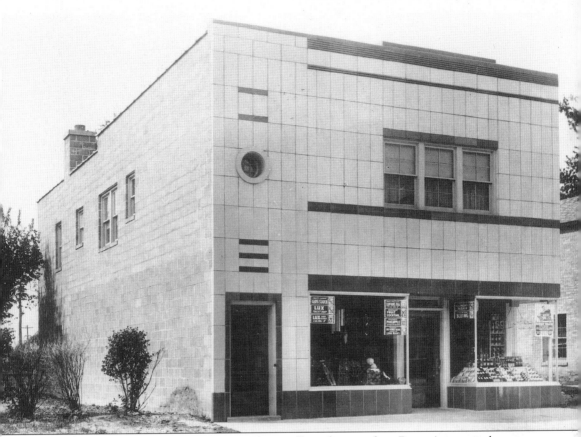

MARKET ON BUSSE AVENUE, C. 1940. This small market stood on Busse Avenue in between Main and Wille. Very little is known about this store. The building was demolished in 2006. In the late 1950s, the façade of the building was covered in rough irregular flat stones, perhaps as a part of a remodeling project. Later, the façade of the building was covered in stucco and heavy timber frames as a part of a downtown development plan. The building was modified to match the Busse building on the other side of the street.

FRANK BIERMANN PUTTING OUT A CAR FIRE, 1940. Frank Biermann was the fifth fire chief in Mount Prospect, a role he held for 26 years. All told, he served with the Mount Prospect Volunteer Fire Department for 41 years. He began his service in 1915 when he turned 18. At that time, the population of Mount Prospect was around 300. When he retired from the force in 1956, the population was close to 14,000. He was involved with the fire department throughout the development of the village and the department. From this photo you can also see that he was a fire chief who didn't mind getting his hands dirty.

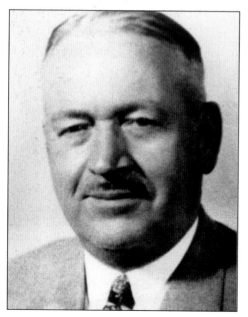

MAYOR INGE BESANDER, 1937. Inge Besander was the third mayor of Mount Prospect. He was a developer by trade and had been based in Mount Prospect for a number of years. Besander took the reigns from Meyn when things appeared to be going in a positive direction. The New Deal had been in full swing for a couple of years and the United States' economy was clearly on the road to a healthy recovery. The sense of optimism, however, was short lived. Soon wars in Europe and Asia began to worry Americans, and by the end of Besander's first term in office the United States had joined the Allied Forces in World War II. The remainder of Besander's political career in Mount Prospect occurred during war time.

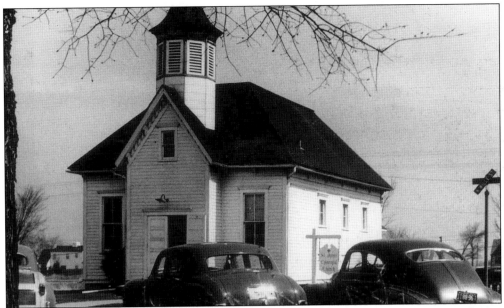

CENTRAL SCHOOL, C. 1940. In the 1930s, it became clear that the school district no longer needed the original Central School. The much larger Central Standard School had been built and had more or less taken over completely. However, the residents of Mount Prospect knew that the original Central School building was too important to the history of the community to let it go to waste. In 1937, the building was sold at auction to the recently organized Saint John's Episcopal Church for $750. The building was then picked up and moved about four blocks to the corner of Wille and Thayer Streets, where it acted as Saint John's Church until 1954, when a larger church was built and the old church was converted to offices.

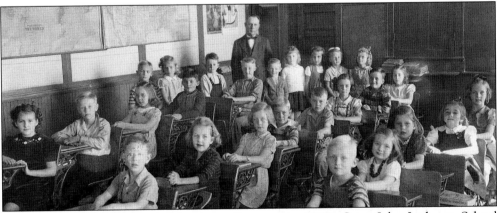

CLASSROOM IN SAINT JOHN LUTHERAN SCHOOL, C. 1940. Saint John Lutheran School was the first school built within the boundaries of what is now Mount Prospect. Saint John Lutheran Church was begun in 1848 and as soon as the church was founded, the members began planning for the education of their children. By 1856, the school had almost 30 students and its first full-time teacher. Education, tradition, and religion were very important to people in the community, and Saint John Lutheran School offered the residents a way to ensure that their traditions would be maintained. In 1901, they built the one-room brick schoolhouse, where this photograph was taken. In 1926, a major addition was put onto the front of the building, allowing there to be two classrooms in the building.

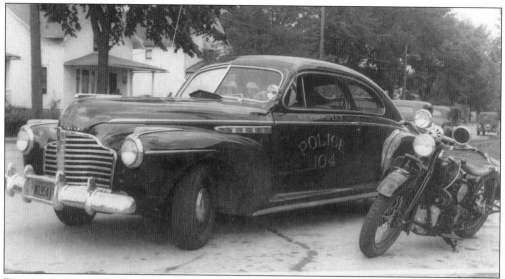

POLICE CAR AND MOTORCYCLE, 1941. In 1940, Mount Prospect's population was around 1,700, which was about twice as large as the village's population had been in 1924 when the first police chief was hired. The growing population required a more sophisticated police department. Originally, the police department also handled public works duties, dividing their time depending on need. By 1941, the department had been able to specialize exclusively on police work, although it still only consisted of two officers. During the late 1940s and early 1950s, the department grew quickly to keep up with the rapidly expanding post-war community.

CIVILIAN DEFENSE COMMITTEE, C. 1943. World War II affected Mount Prospect, as it did all the small communities in America. At the time of the war, the population of the village was around 2,000, and it was still a largely agricultural community. People banded together to help support the troops overseas and prepare the home front. Groups like the Civilian Defense Committee held dances, flea markets, and other fundraisers to raise money to purchase emergency supplies, should they ever be necessary.

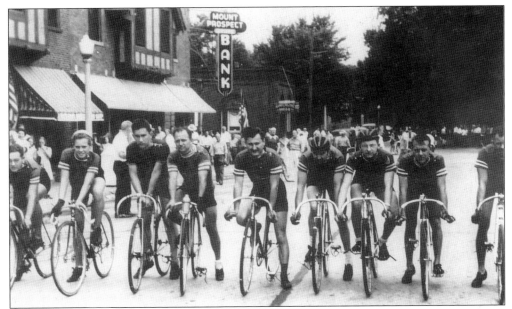

EDISON PARK WHEELMEN AMATEUR BIKE RACE, 1942. The 1942 amateur bike race drew over 80 contestants who raced a 48-mile course. Contestants, spectators, and bicycle enthusiasts from Chicago, Milwaukee, and many small towns surrounding Mount Prospect came for the event. In the end, a man from Chicago named Gunther Lueschen won the race. Mount Prospect only had two contestants, one of whom fell in the tenth mile and another who had a very strong start but finished in tenth place.

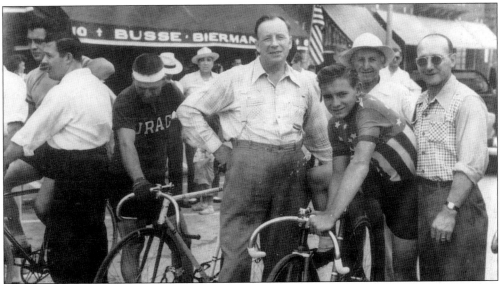

EDISON PARK WHEELMEN AMATEUR BIKE RACE, 1942. William Busse, the main promoter of Mount Prospect, sponsored the Fifth Annual Edison Park Wheelmen Bike Race that started and ended in Mount Prospect. In 1942 the country was focused on World War II, and this was a pleasant distraction that also helped to showcase Mount Prospect. The 25th anniversary of the founding of Mount Prospect would have been 1942, but it is not clear whether the race was a part of the anniversary celebration.

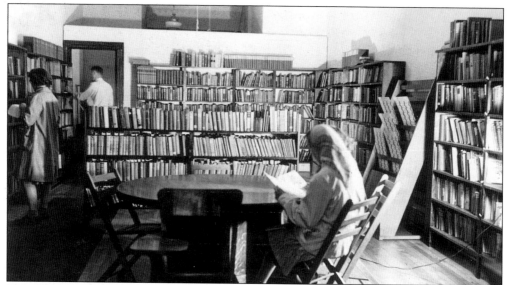

THE MOUNT PROSPECT LIBRARY ON MAIN STREET, 1944. The Mount Prospect Public Library was founded in 1930. Originally the entire library could fit onto a small cart. The cart was kept in a closet in the Central School. When the library was open, they would roll the cart out and when they closed they would just roll the cart back into the closet. This only lasted for a short time, as the collection quickly grew. In 1930, the library moved into a small brick building at the corner of Main and Busse that was the former home of the Mount Prospect State Bank. They operated out of this small space for 14 years before they moved to larger quarters at 111 South Main Street in 1944. They remained in this location for only two years before they were able to construct the first library building at Emerson and Busse.

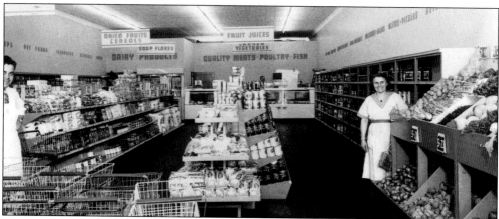

MEESKE'S MARKET, C. 1945. Meeske's Market was a fixture in downtown Mount Prospect for 59 years. The store was begun in 1925, when William Busse Jr. sold the grocery part of his business to Fred Meeske. At that time, the market was located in the Busse Building on Main Street. In 1950, a larger building on the corner of Busse and Main was built to house what was then the main grocery store in Mount Prospect. The store was famous for its exceptional butcher shop and the family's celebration of the community's German roots. In 1973, the Meeske family sold the business, although the store maintained the name. The shop was closed in 1984 after going through a series of owners. The small locally-owned grocery store in downtown was not able to compete against massive chain stores in shopping plazas at the outskirts of town.

POLICE CHIEF GEORGE WHITTENBERG, 1945.
In the movie *The Blues Brothers* the main
characters buy a used Mount Prospect police car.
Years after the movie was made, Dan Aykroyd,
one of the writers, was asked by a member of
the police department why he picked Mount
Prospect. He responded with a letter in 1995
in which he explained that he had been told
by someone in the area that in the early years,
the Mount Prospect Police Department was a
pretty rough bunch that "didn't put up with any
big city interlopers" and that was why he picked
the name. Whether this was true may never
be known, but George Whittenberg was the
chief of police for 28 of the first 40 years of the
department. This photograph would be about
halfway through his career.

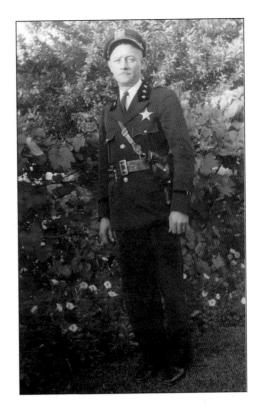

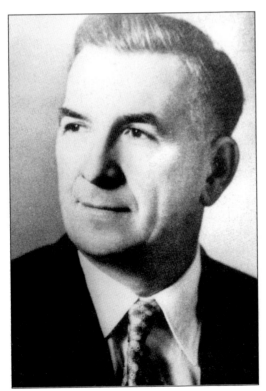

MAYOR MAURICE PENDELTON, 1945.
Maurice Pendelton was the mayor of Mount
Prospect at the beginning of the huge
post-war boom in suburban construction.
When he came into office, World War II
was just coming to an end. He watched
as development in the area went from a
slow trickle to a tidal wave. Professionally,
Pendelton worked as a publisher. He owned
his own publishing business in Chicago,
which specialized in printing lumber and
woodworking trade journals. He took this
expertise and used it to print the *Prospector*,
Mount Prospect's first newspaper.

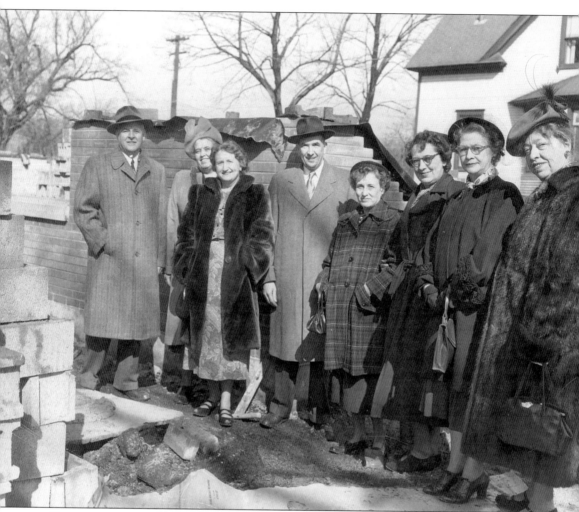

GROUNDBREAKING CEREMONY FOR THE LIBRARY AT EMERSON AND BUSSE, 1949. With the population of Mount Prospect growing quickly after World War II, it was clear that the library needed to expand into a space that was custom-built for it. After passing a referendum, the Library Board purchased the land at the corner of Busse and Emerson Street, just east of the small brick building that had been the second home of the library, and began construction. A time capsule was placed in the cornerstone of this building and was opened in 2003, shortly before the building was demolished. Inside were copies of popular books, records of the library's accounts, and newspaper clippings on events leading up to the construction of the building.

GEORGE L. BUSSE AND BUSINESS ASSOCIATES, C. 1946. While Mount Prospect was developing quickly in the 1940s and 1950s, it maintained its small town feel. Part of the reason for this was that most of the businesses were locally owned and the people involved in developing land here were very heavily involved with local government. People tended to know the developers and many of the important businessmen were also neighbors.

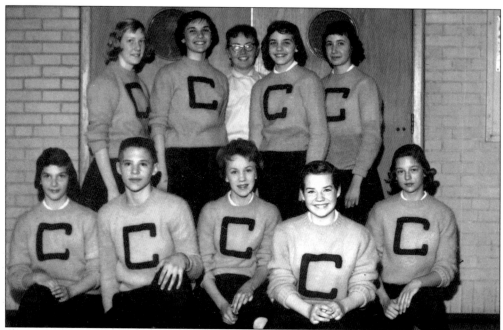

CENTRAL SCHOOL CHEERLEADERS, 1950. As the community of Mount Prospect grew in the post-war era, the schools were forced to adapt to much larger student bodies. Many new extra-curricular activities were started for the baby boom generation, and many clubs and sports associations sprang up to help entertain the numerous new residents.

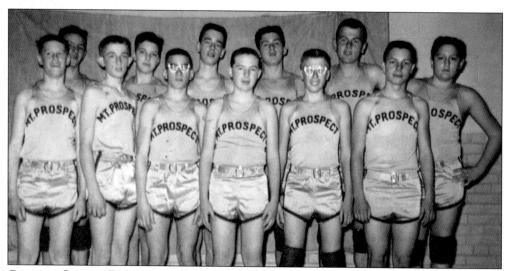

CENTRAL SCHOOL BASKETBALL TEAM, 1950. Central School was the the only public school in Mount Prospect for many years. The original one-room Central School was replaced in 1927 by the larger Central Standard School, which originally had four classrooms. As the community grew, the Central Standard School also grew. There were a number of additions and remodeling efforts to expand the capacity of the school. In 1950, School District 57 finally was able to build a new middle school to take some of the pressure off of the Central Standard School. However, the Central School remained prominent in the community, and anyone who grew up in Mount Prospect in the 1950s or 1960s remembers it.

David Koehler on Edward Street, 1941.
As the village of Mount Prospect developed
it became more of a suburban community,
with many small children, suburban tract
housing, front yards, and baseball teams. In the
1940s, when this photograph was taken, this
transformation was just beginning. Within a few
years it would become an explosive trend.

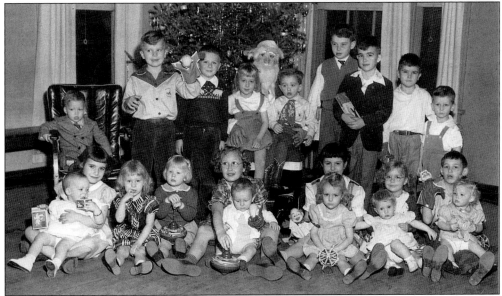

V.F.W. Post 1337 Christmas Party, 1950. After World War II, many soldiers returned to
the Chicago area to find the Windy City in the midst of one of the worst housing shortages in
American history. With many of the able-bodied young men and women overseas, the Chicago
factories had recruited new residents to move to the city. While the factories were pulling new
residents in, federal programs had shifted much of the farming work in America from labor-intensive
to highly mechanized systems. This displaced many agricultural workers, tenant farmers, and small
farm owners who also moved to the cities to find jobs. When the GIs came back there were too
many people for Chicago to house. Thus, with the GI bill and federally subsidized mortgages for new
home construction, a massive movement toward the suburbs started, and places like Mount Prospect
experienced a large growth in the population.

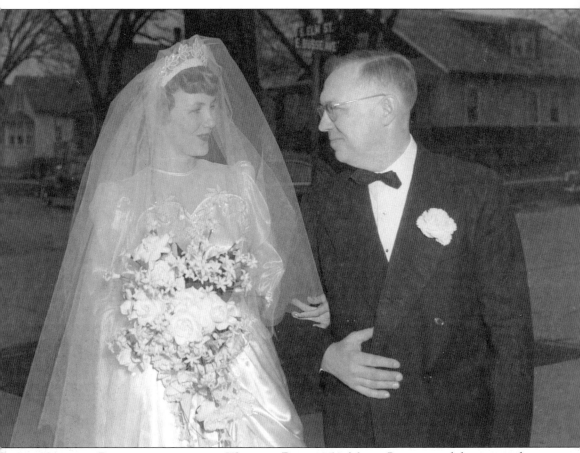

CAROLYN BAUMGARTNER ON HER WEDDING DAY, 1950. Mount Prospect and the surrounding communities were filled with weddings and children in the 1950s. The post-war prosperity encouraged many to start families and federally-sponsored mortgage guarantees allowed many to purchase their dream home in the suburbs. New houses were built and the population of Mount Prospect grew rapidly. One resident at the time remembered there being 144 children on the block. This was great for the kids, but it did have its drawbacks, as the rapid growth led to stress on the school systems.

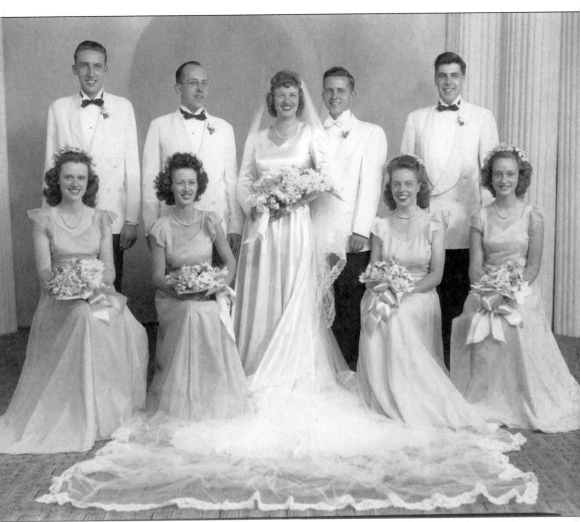

DOLORES HAUGH WEDDING PICTURE, 1946. The baby boom could be clearly seen in Mount Prospect. In the late 1940s and through the 1950s, many young couples were married and moved out of the cities into the suburbs to start a family. Dolores Haugh was part of the post-war suburban expansion, although in Mount Prospect she became much more than just an example of a national trend. Haugh was hugely influential in the development of the community of Mount Prospect. She was the first village information officer, the executive director of the Chamber of Commerce, and a founding member of the Mount Prospect Historical Society.

LIBRARY BUILDING, 1950. As the population of Mount Prospect grew, the Mount Prospect Public Library grew with it. The library began with meager means, but the enthusiasm of the patrons quickly helped to expand the collection and the services offered in the community. Over the years the library has had a number of homes, but the building seen in this picture was the first one that was actually built to be a library. The library was based in this building for 28 years. Eventually the library outgrew the building and a new one was built. This building then became the village's Senior Citizen Center, until it was demolished in 2002.

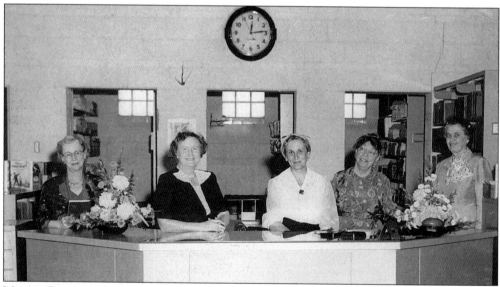

MOUNT PROSPECT PUBLIC LIBRARY, 1950. The public library became a meeting place for many people in the community and it attracted some of the most famous local names. In this picture, from left to right, are Ruth Carlson, Irma Schlemmer, Meta Bittner, Bertha Ehard, and Louise Koester. Meta Bittner was central to the founding of the library and was very involved with the Mount Prospect Woman's Club. Bertha Ehard was the founder of the Mount Prospect Campfire Girls and was responsible for all of the streets in Mount Prospect with Native American names, such as Wapella or Hi Lusi. Finally, Louise Koester was the first doctor in Mount Prospect.

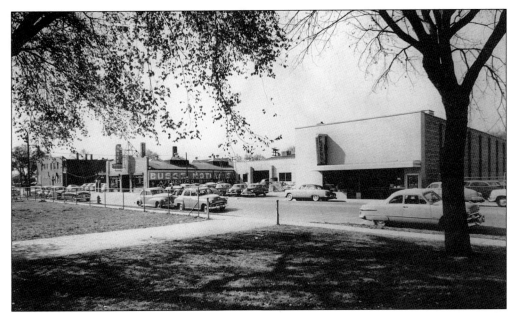

MAIN STREET, C. 1953. The Prospect Theater was a downtown landmark for decades. At the time this photograph was taken, the theater was showing *Kon Tiki* (1951) and *Remains to be Seen* (1953), starring Angela Lansbury. Next door to the theater is the showroom and service department of Busse Buick. Further down the street you can see the Mount Prospect State Bank. This picture is taken from the lawn of the Central School.

MOUNT PROSPECT STATE BANK, C. 1950. Originally built to house William Busse's Hardware store and Busse Buick in 1912, this building became the home of Mount Prospect State Bank in 1928. The heavy timber Bavarian dormer was added in the 1940s to make it match the other buildings on the block. The marble and glass bricks on the façade were added during the 1950s and later removed. The large neon sign was also added in the 1950s.

ORIGINAL MOUNT PROSPECT STATE BANK BUILDING, C. 1950. This small square building was a big player in the development of Mount Prospect. It was built in 1911 to house the Mount Prospect State Bank. This bank was largely responsible for the boom in housing construction in the community in the 1920s and 1950s. The bank operated out of this small building until 1928, when it moved across the street to the building that was originally built for Busse Hardware. In 1930, a young Mount Prospect Public Library moved into the building. The library had originally been housed in the Central School, but as it developed a larger collection it needed to move into a building of its own. The library operated out of this building until 1944, when they moved around the corner to 111 South Main Street. A few years later the building was demolished and the land was turned into a parking lot.

MAYOR THEODORE LAMS, 1953. Theodore Lams was mayor of Mount Prospect through a large part of the post-war boom. Lams had been a trustee from 1945 until he became mayor in 1953. He certainly saw Mount Prospect grow. While he was mayor, the population more than doubled, and the developed area of Mount Prospect grew immensely. Lams may have been Mount Prospect's most artistic mayor. He received his Masters degree in Music and worked as a professor of music at Northwestern University for the majority of his professional career.

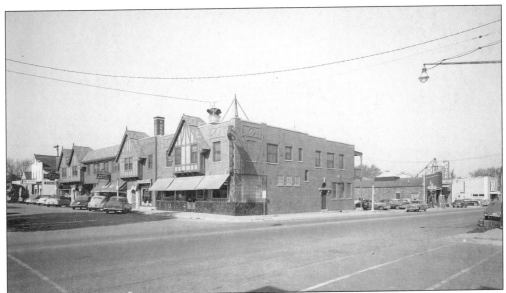

INTERSECTION OF BUSSE AND MAIN, C. 1954. You can see the thriving downtown Mount Prospect of the 1950s in this picture. In some ways this was a heyday for the downtown area. Within ten years Randhurst and the Mount Prospect Plaza would be built, drawing consumers toward the fringes of the community. In this picture you can see the Prospect Theater all the way to the right, Busse Buick next to it, the Mount Prospect State Bank on the corner, Busse-Bierman Hardware, the Bowling Alley, and Wille's Tavern.

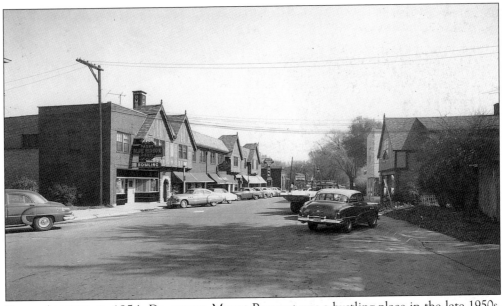

BUSSE AVENUE, C. 1954. Downtown Mount Prospect was a bustling place in the late 1950s. Busse Avenue was one of the main centers in town, along with Northwest Highway, Main Street, and Prospect Avenue. In this photo, you can see the bowling alley that was in the Busse Building, the inside of which was burned out in a fire in the 1960s and never re-opened. You can also see Busse-Biermann Hardware, and the Mount Prospect State Bank. On the other side of the street there is a barber shop and a grocery store.

LINCOLN JUNIOR HIGH SCHOOL, C. 1955. The baby boom hit Mount Prospect with full force during the 1950s. This created a need for additional schools. It caused School District 57 to pay some of the highest salaries for teachers in the Midwest due to the huge demand for teachers in the rapidly expanding Chicago suburbs. The decade of the 1950s witnessed the construction of six separate schools within District 57 alone. The first new school to be built was the Lincoln Junior High School. The building of Lincoln Junior High helped ease the overcrowding problem in the second Central School, which had been built in 1927 and was the only public school in Mount Prospect until 1950.

DR. BAGNUOLO GIVING POLIO SHOTS AT SAINT RAYMOND SCHOOL, 1955. In the 1940s, there were five churches that served the community of Mount Prospect—three Lutheran, one Baptist, and one Episcopalian. As the community continued to diversify in the post-war expansion, the need for churches to serve other denominations also grew. In the late 1940s, the Catholic Women's Club began working to bring a Catholic parish to the community. After years of work, in 1949 Father O'Brien arrived and gave the first mass in the basement of the Central School. The parish grew very quickly and opened the doors to its school in 1954. The school was so popular that by the end of the decade they had to have two schedules for the students: one group came in the morning and one group came in the afternoon.

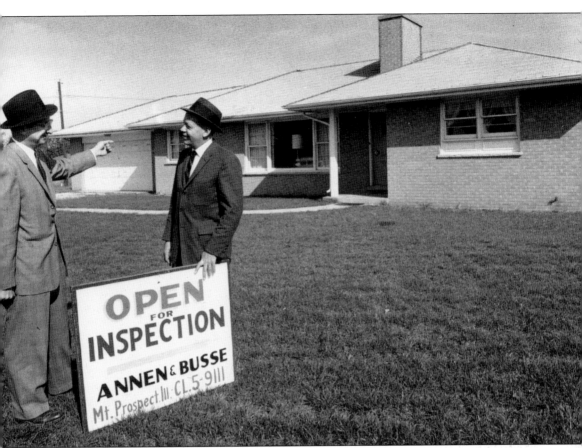

ANNEN AND BUSSE REALTY, C. 1955. The real estate partnership between Edward J. Busse and Bill Annen was formed in 1949 with the creation of Annen-Busse Realty. They soon had offices in Arlington Heights, Palatine, Schaumburg, Elk Grove, Hanover Park, and Mount Prospect. The business was founded just as the massive post-war growth began in the northwest suburbs of Chicago. It was involved in housing many of the new suburbanites, both by selling homes and by building them. The business remained successful for 30 years, and finally closed when Annen and Busse retired in 1980.

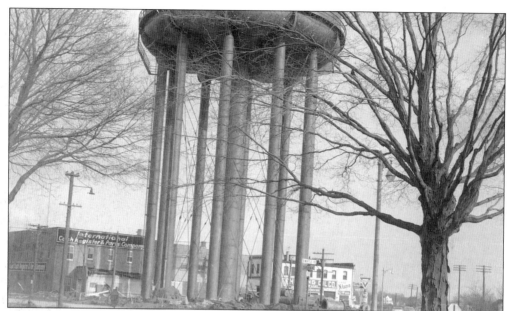

WATER TOWER ON NORTHWEST HIGHWAY, 1956. As the population of Mount Prospect grew, the need for services such as water also grew. Due to the rising demand, Mount Prospect began construction on a new water tower in 1955. The water tower has been a fixture in the community ever since. The tower was painted gold for the 50th anniversary of Mount Prospect's incorporation, and an image of it was used as the central image on all the material printed for the celebration. Later it was painted for the U.S. Bicentennial, and an image of it was on the back of the commemorative coin. It is still standing today, although it has not been used for almost 20 years, as Mount Prospect's water supply is now piped from Lake Michigan.

POLICE INVESTIGATION OF AN AUTO ACCIDENT, 1956. This photograph of a policeman investigating a minor car accident shows some interesting things about Mount Prospect in 1956. This image shows how quickly Mount Prospect was growing. While there are plenty of houses and a small crowd of people, there are no gardens, very few cars, and no decorations. The trees are all brand new; they have not had time to grow. The community was growing so quickly that new subdivisions would fill entirely before the grass had been planted. Because most of this area had been farms, all of the trees were new.

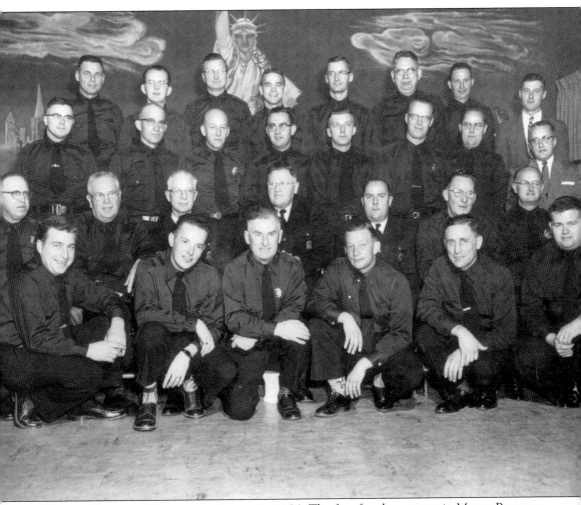

MOUNT PROSPECT VOLUNTEER FIREMEN, 1956. The first fire department in Mount Prospect was formed in 1913, before the village was incorporated. This group of volunteers did their best with eight buckets, a couple of ladders, two axes, and two pikes. As the community grew, the fire department also expanded. The year 1946 saw the first paid, on-call firefighters and by the time this picture was taken, the department was on its second fire engine. However, they would have to wait until 1960 before they hired a full-time professional firefighter. This photo shows some of the community leaders who were involved: there are six Busses, two Willes, two Meeskes, two Haberkamps, a Kruse, and a Biermann in this picture.

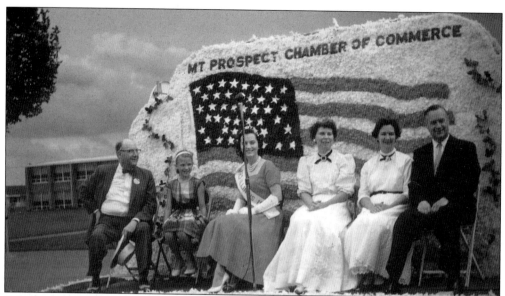

Float in the 40th Anniversary Parade, 1957. Mount Prospect in the 1950s was a rapidly growing community that was becoming increasing aware of itself as a major suburban community. Part of this self-awareness was seen in the community beginning to discuss its history and its relation to the nation as a whole. Seated on this float are: at the far right Mayor Theodore Lams, and next to him, Hester Kline Pendleton and Velma Welsh. Pendleton and Welsh were asked to compile the history of Mount Prospect and present it to the community but were told "No more than five minutes."

Lion's Club Float for Fourth of July Parade, c. 1957. With the massive post-war growth of Mount Prospect, many clubs and organizations flourished in the community. Organizations like the Lions Club, the Rotary Club, the Chamber of Commerce, and other business and social groups flourished with many new, active, and young residents coming into town. These clubs and organizations worked to develop a greater community feeling through parades, parties, and village improvement projects.

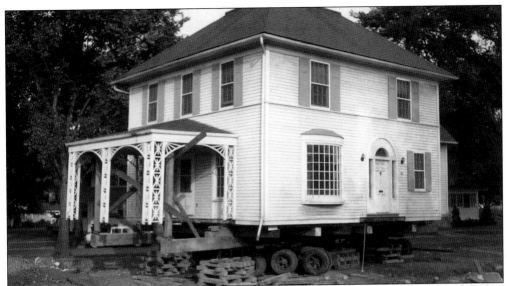

WILLIAM BUSSE'S FIRST HOUSE ON THE MOVE, 1958. Mount Prospect has a much longer tradition of moving buildings than many residents may know. The first train station was moved to become a house; a barber shop was moved because of a title dispute; the first public school was sold to a church and moved; three houses were moved into Mount Prospect to house the original Saint Paul Lutheran Church and School, and then later moved again to become private homes; the Moehling General Store was moved to make way for redevelopment; and at least three Busse houses were moved over the years. This house, William Busse's first home in Mount Prospect, has been moved twice. The building originally stood at the corner of Main Street and Busse Avenue but it was moved in the late 1940s to Emerson Street to make room for the construction of Meeske's Market. Then in October of 1958, both of William Busse's houses were moved out of downtown to Central Road, where they still stand.

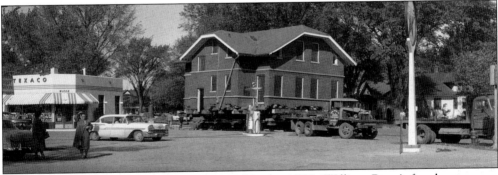

WILLIAM BUSSE'S SECOND HOUSE ON THE MOVE, 1958. William Busse's first house was a beautiful white frame building with decorative wrought ironwork along the roof line. With a sunken garden behind the house and a formal parlor, this house was certainly the most impressive space in Mount Prospect. As Commissioner Busse was the founder of a bank and an elected official, it was important for him to have an appropriate space for entertaining. But as Busse grew older and his children moved out, he felt he didn't need such an elaborate home anymore, so he built his second home and gave the first to his oldest son, William Jr. Eventually, the development that Busse had championed caught up with his houses. As downtown expanded, there was a need for the space. So both houses were moved and the third home of the Mount Prospect State Bank, which later became Village Hall, was built in their place.

GEORGE L. BUSSE, C. 1958. George L. Busse followed in his father's footsteps and became a real estate agent and developer. George L. Busse's father, George Busse, was responsible for the first addition to Mount Prospect, Busse's Eastern Addition, in 1923. From this initial investment, the Busse real estate business developed. The company was originally called the Mount Prospect Development Company; it was later called Busse Realty, and finally, George L. Busse and Company. The company was responsible for subdividing many farms in the northwest suburbs, as well as handling the sale of land for both Randhurst and Woodfield shopping malls.

INTERSECTION OF BUSSE AVENUE AND MAIN STREET, C. 1958. The heyday of Mount Prospect's downtown was in the late 1950s and early 1960s. There were many locally owned businesses that formed a strong sense of community and worked to give Mount Prospect its small-town feel. Their concentration in the center of town made it possible to walk from shop to shop. This was also the time of Mount Prospect's greatest population boom, fueled by post-war economic prosperity, federally-backed mortgage guarantees, the baby boom, and the huge migration out of city neighborhoods.

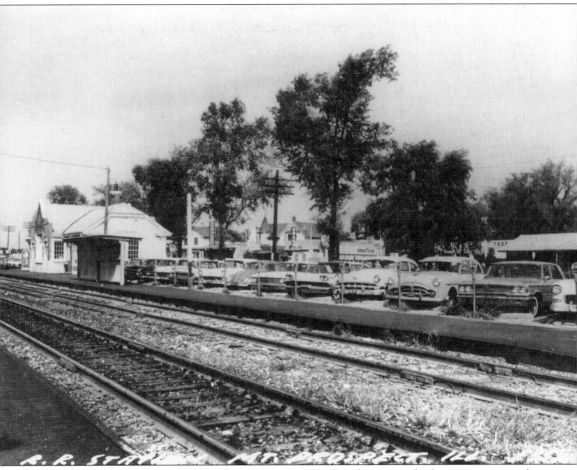

TRAIN STATION, C. 1959. As Mount Prospect developed into a suburban community, the trains shifted from carrying milk and onions to Chicago, to carrying commuters to Chicago. The town adjusted too, and parking lots replaced the onion drying sheds. Many of the families who had recently moved to Mount Prospect had breadwinners who worked in Chicago and the commuter trains made living in Mount Prospect feasible.

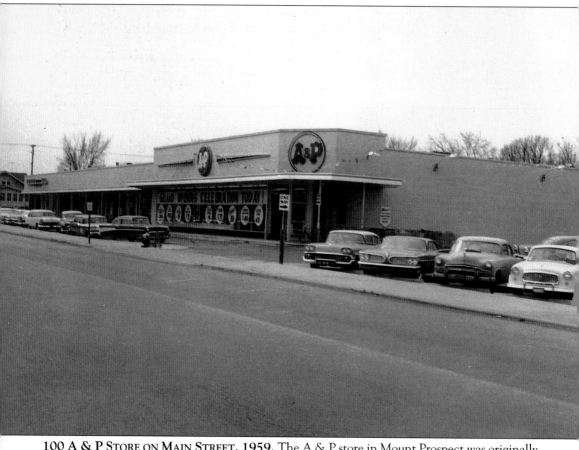

100 A & P STORE ON MAIN STREET, 1959. The A & P store in Mount Prospect was originally in a storefront on Northwest Highway. But in the late 1950s, it moved to one of Mount Prospect's first shopping plazas. While this may have been the first shopping plaza, it was not the only one and was certainly not the largest. Three years after this photograph was taken the Mount Prospect Plaza and Randhurst would both open, which would increasingly draw business out of the downtown towards the periphery of the village.

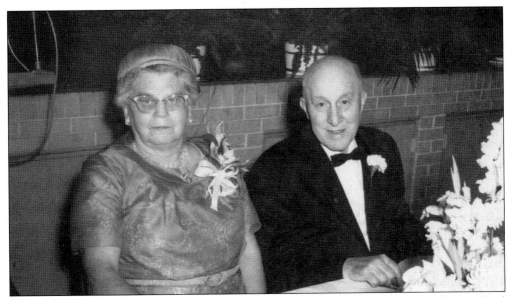

PASTOR AND MRS. J.E.A. MUELLER, 1960. J.E.A. Mueller was the first pastor of Saint Paul Lutheran church. He opened the church on January 12, 1913, holding the first service on a day that was reported to be ten degrees below zero. This was after he had been up until four in the morning preparing the church the night before. He was young and energetic and he soon became a leader in the community. He and his wife, Sophie, met through Saint Paul Lutheran Church. She was the church organist and also the fifth child of William Busse, one of the church's founding members.

FRANK BIERMANN, C. 1960. The Biermann family moved to Mount Prospect in 1911, encouraged by William Busse, who wanted Fred Biermann to help Mount Prospect improve its roads. Eight years later Frank Biermann married Busse's daughter, and 18 years after coming to Mount Prospect, he took over Busse's Hardware store, creating Busse-Biermann Hardware. Frank Biermann was very active in the community, most notably as a long-time member of the Mount Prospect Fire Department. Frank Biermann joined the volunteer fire department in 1915 and didn't quit until 1956, after serving 28 years as fire chief and a total of 41 years total on the force.

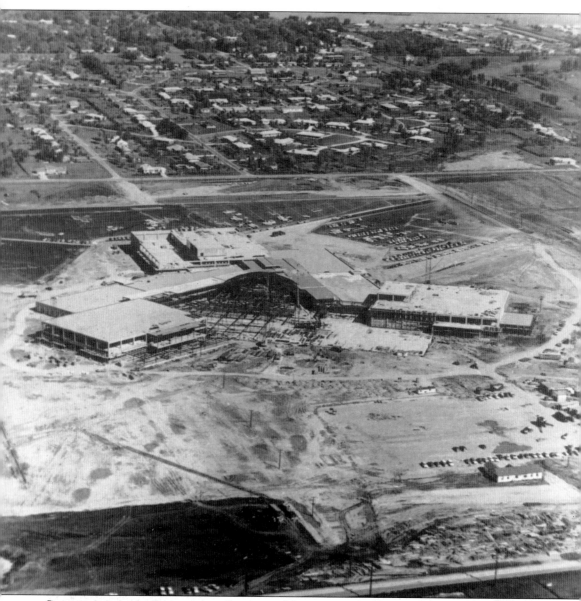

CONSTRUCTION OF RANDHURST SHOPPING MALL, C. 1960. Randhurst Shopping Mall was an incredible project in its time. Built on top of one of the last farms in Mount Prospect, it was started in 1958 and completed in 1962. When it opened, Randhurst was the largest air-conditioned space in America and one of the largest shopping areas in the country. Those who lived in Mount Prospect at the time remember the mall being so crowded that you could barely walk. Many of the shoppers were people who drove out from Chicago to go to a new shopping mall, which was quite a novelty at the time.

Four

POST-BOOM MOUNT PROSPECT

FROM THE END OF THE BABY BOOM TO TODAY, 1960–2000

Mount Prospect became a mature and fully-developed community following the rapid growth of the post-war boom years. With the population growing at a much slower rate, the community had time to step back and review the rapid growth of the earlier years. Many local organizations grew and helped define the community identity. There have also been challenges in the recent past. With many of the children of the baby boom having grown and moved out, the schools faced falling enrollments. Locally owned businesses have faced increased competition from large developments on the outskirts of town. Mount Prospect has worked to meet these challenges, while still maintaining the hometown feel that makes Mount Prospect a place where "friendliness is a way of life."

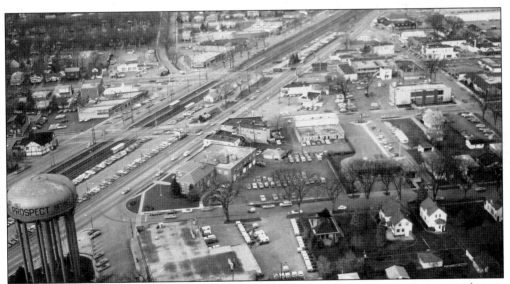

AERIAL VIEW OF DOWNTOWN, 1967. The look of downtown Mount Prospect when it celebrated the 50th anniversary of the incorporation of the village is very different from how it looked in the 1920s. The town was no longer an isolated development surrounded by farms, but had become developed in all directions. This picture is a little misleading, as it only shows downtown and the more developed spaces. There were still some open spaces in the community in the 1960s, but with the suburban development of the 1950s and 1960s, this land was too valuable to remain farmland for long.

115

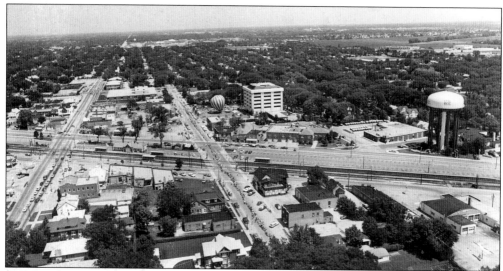

AERIAL VIEW OF DOWNTOWN MOUNT PROSPECT, 1976. By 1976, the baby boom generation that built this town was largely grown and their parents found themselves with much more time. Perhaps because of this, a number of organizations in the community began developing large community projects. The celebration of the United States Bicentennial was certainly one of these projects. The celebration became a major event in Mount Prospect. As you can see in this photo, the water tower was painted for the Bicentennial, and the parade going down Emerson Street may have contained the entire population.

OPENING CEREMONY FOR THE MOUNT PROSPECT PLAZA, 1962. In the 1960s, Mount Prospect began to incorporate commercially developed areas around the outskirts of town. The Mount Prospect Plaza was the first strip mall in the community and one of the first in the upper Midwest. These types of developments were typically done by private development companies on unincorporated parcels, and incorporated into the neighboring community either while they were under construction or soon after they were finished. Large-scale commercial developments like this changed the dynamics of town; large businesses were able to move into somewhat isolated areas away from downtown where there was ample parking. This allowed major national chain stores the space they needed, which gave residents a greater selection at a lower price but also hurt locally owned businesses, the downtown area, and the pedestrian feel of the village.

CLARENCE O. SCHLAVER, C. 1961. Clarence Schlaver was a village trustee for seven years, beginning in 1954 and ending when he was elected mayor in 1961. C.O. Schlaver was a professional newsman: he was a reporter and editor for the *Star-Courier* and later on the editorial staff of the *Chicago Daily News*. Schlaver was also involved with a number of organizations. In 1972, he became the executive director of the Mount Prospect Chamber of Commerce, a position he held until 1979, shortly before his death. He was a founding member of the Mount Prospect Historical Society, and was involved with the Lions Club at both the local and state-wide level.

ALBERT E. BUSSE HOUSE ON THE MOVE, 1960. Mount Prospect has moved many buildings over the years. Both of William Busse's houses were moved, the Central school was moved, and the Moehling general store was moved. This building was built for Albert Busse, although he only lived in it for a few years. Later in its history it was used as the headquarters for School District 57, and finally it was purchased in 1959 and moved out of the center of downtown. It was moved to Pine Street, where it still stands today. This building's next door neighbor was also moved. In 1976, Christine Busse's house was moved to make way for the construction of a new six story Mount Prospect State Bank Building, which now houses BankOne.

117

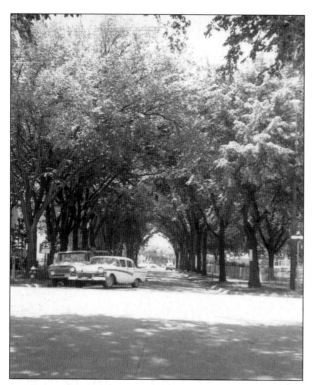

INTERSECTION OF EMERSON AND BUSSE, 1964. By the mid 1960s, Mount Prospect had developed into a mature suburban community. The population was still growing but not at such a frantic pace. The baby boom was winding down and the number of new subdivisions in town decreased significantly. As the rapid development slowed, it was possible for the trees and landscapes to grow and mature.

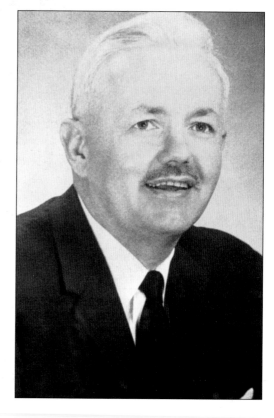

MAYOR DANIEL CONGREVE, 1965. Daniel Congreve was a "Back to Basics" kind of mayor. He ran on a platform of returning to the traditional values of the community and campaigned by riding around town in a horse-drawn wagon. He is the only mayor who left office with the boundaries of Mount Prospect unchanged, as the community did not expand at all during his administration. Part of the reason for this was that he spent much of his time in office involved in legal battles with Salvatore DiMucci, a regional developer.

EARL MEESKE, C. 1965. Meeske's Market was a fixture in downtown Mount Prospect for years. The store began in 1925, with Fred Meeske taking over the local grocery store from William Busse Jr. Fred Meeske retired in the 1950s and his two sons, Earl and Fred Jr. took over the store. The store was famous for its exceptional butcher shop. In 1965, the store was remodeled to celebrate the German heritage of both the Meeskes and Mount Prospect. In 1973, Earl and Fred Meeske sold the business.

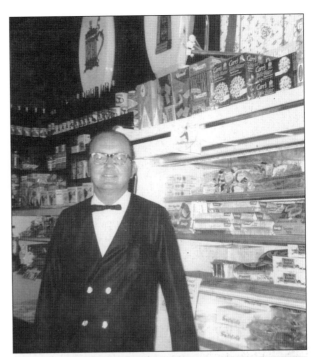

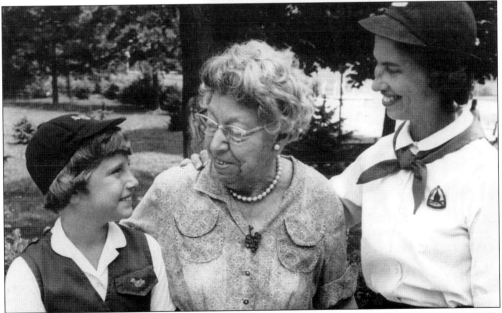

BERTHA EHARD AT THE CAMP FIRE GIRLS 40TH ANNIVERSARY CELEBRATION, 1967. "Worship God, seek beauty, pursue knowledge, be trustworthy, hold on to health, glorify work, be happy." This motto was adopted as the law of the Mount Prospect Campfire Girls, which was founded by Bertha Ehard in 1926 and was granted a charter from the National Council of Campfire Girls in 1927. After working all day in Chicago, Bertha would ride the train home and quickly bring a wagon of coal to the Central School in hopes of warming it up before her troop members arrived. Bertha was active in this group for years. She was also a member of the library board for 15 years, holding the position of treasurer for 12 of those years.

MAYOR ROBERT TEICHERT, 1969. Robert Teichert had been a trustee for four years before becoming mayor. He served for eight years as mayor of Mount Prospect, in a time when the community was going through a difficult adjustment. The post-war boom was over, the population of the community was aging, school enrollment was down, and the municipal budget was over-extended. Teichert and the trustees struggled with these problems over the years, bringing the community back to a stable position. Teichert was responsible for the single largest annexation in Mount Prospect history. The area of New Town in the northwest area of the village added almost two square miles and close to 10,000 people to Mount Prospect.

JOHN WEBBER EXAMINES PARTS OF THE HISTORICAL SOCIETY COLLECTION, c. 1972. John Webber was the husband of a founding member of the Mount Prospect Historical Society and was also the second president of the organization. In this picture, he is looking at a historical ledger that is on display. For a couple of years, the historical society operated out of a small space in the first municipal building on Evergreen Avenue. Later, the Society was able to move into the 1901 Saint John Lutheran Schoolhouse, and eventually opened the Dietrich Friedrich's House Museum in downtown Mount Prospect.

Doris Webber Displaying a Part of the Historical Society Collection, 1972. Twenty years after the start of the baby boom, there was a large rise in the number of local organizations here and around the country. With children moving away or at least needing less attention, many people found themselves with significantly more time to join clubs and organizations. The Mount Prospect Historical Society was one of these organizations. Founded in 1967 by Doris Webber, Meta Bitner, Dolores Haugh, Edith Freund, and Gertrude Francek, it quickly grew in membership.

The Whittenberg Memorial Fountain, c. 1975. George Whittenberg was a member of the Mount Prospect Police Department for 33 years, and the chief of police for most of that time. He resigned his post in 1965, having seen the community change dramatically during his tenure. Four years later he died. His funeral procession included 50 cars that passed by the police station one last time. In 1975, the village built this waterfall and fountain as a memorial to his years of service. The monument stood at the base of the water tower, very close to the police station in which Whittenberg had spent so much time.

SAINT RAYMOND'S CATHOLIC CHURCH, 1974. Saint Raymond's Church has been one of the fastest growing churches in Mount Prospect since it was founded in 1949. The parish tripled in membership in its first three years. By 1961, the church was holding additional services at Lincoln Junior High School. A new church was dedicated in 1962 and the original church became an auditorium.

THE GUARDSMEN DRUM AND BUGLE CORPS, C. 1969. With the large growth of the student population in the northwest suburbs of Chicago, there was also a growth in the activities offered to them. The Guardsmen were founded in 1961 to offer students lessons in teamwork and competitive marching bands. The corps was formed by students from Mount Prospect, Arlington Heights, Des Plaines, Elk Grove, Hoffman Estates, Palatine, Prospect Heights, Roselle, Schaumburg, and Streamwood. Throughout the 1960s they traveled around the country and throughout Canada for competitions.

E-Hart Float in a Fourth of July Parade, c. 1976. The E-Hart Girls were a service organization for young women in Mount Prospect. Inspired by Bertha Ehard, the founder of the Mount Prospect Campfire Girls, the group was formed in 1967. The five points of the star on the E-Hart symbol represented the five ideals that the group hoped to instill in the girls: Service, Training, Arts, Recreation, and Social Graces, or S.T.A.R.S. The group performed many civic services in the community, including visiting hospitals and performing plays for individuals in nursing homes. They also had a flare for parades, winning several awards over the years.

Dedication of the Mount Prospect Historical Society School Museum, 1976. The United States Bicentennial was a very important event in Mount Prospect and throughout the country. Many people began to think more about the history of the country and the history of their hometowns. While the Mount Prospect Historical Society had been founded eight years before the Bicentennial, the group had not had its own museum. Riding the enthusiasm for the national birthday, the society was able to make arrangements with Saint John Lutheran Church and raise the needed money to convert the 1901 Saint John School into Mount Prospect's first museum. Seen here at the dedication are former mayor and director of the Chamber of Commerce Clarence O. Schlaver and historical society founding member Dolores Haugh.

DEMOLITION OF THE CENTRAL SCHOOL, 1975. The Central School was a fixture in Mount Prospect for 80 years. The original Central School was built in 1895, as the first public school in Mount Prospect and the first home of District 57. In 1927, the second Central School was built to house the growing population. The school was later expanded and remodeled as the population continued to increase. In the 1950s, with the massive growth of the village and the baby boom, six new schools were built in the district. As that generation grew up, there was no longer a need for all of those schools and a number of them were closed and some demolished. The Central School was one of the first to go. The land was purchased by the Mount Prospect Public Library and in 1977 the library opened at that location.

PUBLICITY PHOTOGRAPH FOR RANDHURST SHOPPING MALL, C. 1977. When Randhurst opened its doors in 1962 it was a huge attraction. At the time, it was one of the first shopping malls in America and was massive by the standards of the time. In the late 1960s and 1970s, the Randhurst Corporation began hosting special events, such as circuses, fashion shows, children's fairs, and educational programs. The mall also brought in a number of celebrities such as Robert F. Kennedy, Arnold Schwarzenegger, Lou Ferigno, and cast members from the *Planet of the Apes*. As other malls opened in the area, the attraction to Randhurst declined but it remained a major center of shopping in the community through the 1990s.

**SAMMY SKOBEL OUTSIDE HIS HOT DOG STORE,
c. 1978.** Sammy Skobel is one of Mount
Prospect's local celebrities. He was a famous
Roller Derby Champion during the sport's
heyday. He was born on Maxwell Street in
Chicago and became legally blind at the age of
four from scarlet fever. However, Sammy never
let this hold him back; he tried out and made
one of the Roller Derby teams. Without telling
anyone that he was blind, he went on to glory
in the sport, winning MVP awards, and setting
the speed record for the mile. Following his
retirement, he moved to Mount Prospect and
started Sammy Skobel's Hot Dogs Plus on Main
Street next to Busse Avenue. This store became
an institution in the community, and it is still
fondly remembered by many who grew up in
town. Sammy has also gone on to start golf and
downhill skiing organizations for the blind.

MAYOR CAROLYN KRAUSE, 1977. Carolyn Krause has been involved in politics in one way
or another since 1971. She began by being appointed to the Mount Prospect Zoning Board.
Six years later, she was the first woman elected to hold the office of mayor in Mount Prospect.
Taking the village administration to a higher level of professionalism, she outlined plans for
the future development of Mount Prospect and worked to decrease property taxes. She is
also responsible for the annexation of the N.I. Gas property, which has become Kensington
Business Center. After 12 years as mayor, she stepped down and focused on statewide politics.
She became the state representative for parts of Mount Prospect and other surrounding
communities in District 66.

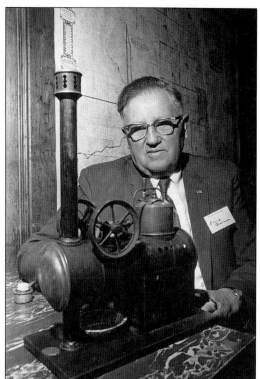

FRANK BIERMANN, C. 1978. Along with running a business in town for years and serving on the volunteer fire department for 41 years, Frank Biermann was also involved in many local organizations. He was influential in the Mount Prospect Historical Society. Here he is seen demonstrating how a steam engine worked so that the audience would have a greater understanding of what life was like in Mount Prospect with the early trains, tools, and production. He was also one of the founders of the Mount Prospect Lions Club.

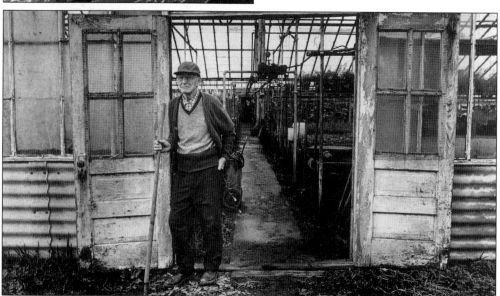

BUSSE FLOWERS GREENHOUSES, 1978. Originally, Busse Flowers was primarily a greenhouse that shipped the flowers grown here into Chicago and from there around the country. As Mount Prospect developed, the retail side of the business expanded. In 1947, an addition was built to house the retail sales, and Busse Flowers also began offering pottery and gifts. The retail side was expanded and remodeled in 1951 and again in 1964. By the end of the 1970s, retail sales was the main focus of the business. So in 1987, as a part of a downtown redevelopment, the greenhouses and the original shop were demolished to make way for a new store.

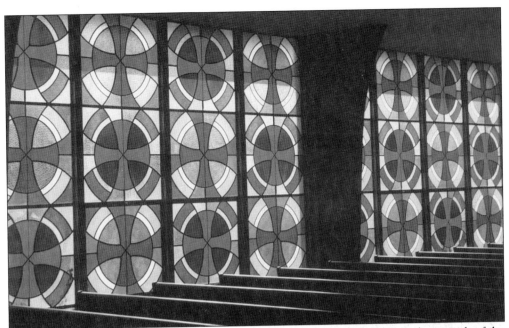

STAINED GLASS AT SAINT RAYMOND'S CATHOLIC CHURCH, C. 1985. This photograph of the stained glass windows at Saint Raymond's Church was taken by George Stiener. He wanted to document the original design of the windows before they were replaced. In 1988, the church was renovated and a series of new stained glass windows were put into the church. The new windows were designed by Robert Harmon and visually tell stories from the Bible.

MAYOR GERALD "SKIP" FARLEY, 1989. Gerald Farley is the longest-serving mayor in the history of Mount Prospect, first elected in 1989. He is approached only by Carolyn Krause and William Busse, each of whom served 12 years. Prior to his term as mayor, he was a trustee from 1979 to 1989. Mayor Farley's long career in public office has not been without challenge. In 1997, due to a technicality, his name was taken off the ballot. However, in a demonstration of local support, Mayor Farley became the first and only write-in candidate to win a local office.

DEMOLITION OF THE BUSSE SCHOOL, 1994. The rapid expansion of Mount Prospect in the 1950s had its drawbacks. In the late 1970s, the number of children in Mount Prospect dropped dramatically, as many children from the baby boom era grew up and moved out. School districts had built many schools in a short period of time to handle the massive explosion of the population in the 1950s, but by the early 1980s were having problems filling their schools. Busse School was built in 1956, one of six schools built by Mount Prospect School District 57 in the 1950s. It reached its zenith in 1974, when the school principal, Robert Ferguson, was named the best school administrator in Illinois. The next year he went to Central School to manage the last year of its operation. Central was demolished in 1975; Busse School was closed in 1982 and then demolished in 1994, after housing a private school for gifted children for a decade.

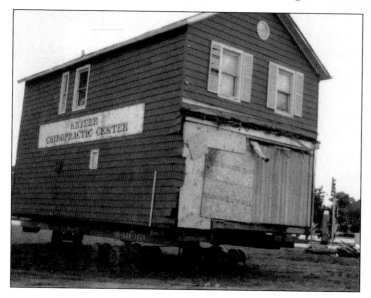

MOVING THE MOEHLING GENERAL STORE, 1999 (PHOTO BY GEORGE STIENER). The first store in Mount Prospect was housed in this building. It was also the first post office and a gathering place in the community. The building has stood in Mount Prospect for over 120 years, although as you can see, it has not always stood in the same place. The Moehling store was originally at the corner of Main Street and Northwest Highway. Over the years many businesses were based in this building, and by the late 1990s the building was in poor condition. About this time the Village Board voted on a downtown redevelopment plan which included the complete demolition of the block that this building stood on. Realizing that this would be a tragic loss of community history, there was a movement to save the building. Through community groups, local citizens, and Village Trustee Paul Hoefert, a solution was devised. The building was moved to Pine Street and completely renovated for commercial use. The building still stands, the redevelopment was able to go on, and the community is still able to appreciate its roots.